THE
PRE-RAPHAELITES

THE
PRE-RAPHAELITES

CHARTWELL
BOOKS, INC.

Published by Chartwell Books
A Division of Book Sales Inc.
114 Northfield Avenue
Edison, New Jersey 08837
USA

0-7858-0988-0

This book is produced by
Quantum Books Ltd
6 Blundell Street
London N7 9BH

Project Manager: Rebecca Kingsley
Project Editor: Judith Millidge
Designer: Wayne Humphries
Editor: Clare Haworth-Maden

The material in this publication previously appeared in
The Art of the Pre-Raphaelites

QUMTPRP
Set in Times
Reproduced in Singapore by United Graphic Ltd
Printed in Singapore by Star Standard Industries (Pte) Ltd

CONTENTS

The Formation of the Pre-Raphaelite Brotherhood

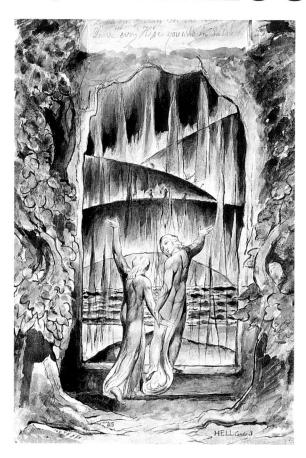

The Pre-Raphaelite Brotherhood was founded in London in the fall of 1848, adopting its name in deference to the painters working before the time of Raphael. This secret society had been convened by Dante Gabriel Rossetti, William Holman Hunt, and John Everett Millais, and was extended to include two more painters: James Collinson and F. G. Stephens; a sculptor: Thomas Woolner; and a tax clerk: William Michael Rossetti, brother of Dante Gabriel and diarist and secretary to the Pre-Raphaelite circle.

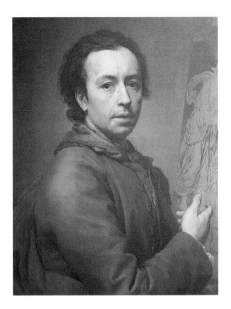

Above; Anton Raffael Mengs, Self Portrait. *Mengs'swork illustrates the academic ideal of the period, which viewed antiquity as providing a timeless artistic standard.*

In the first half of the nineteenth century, the overwhelming authority of academic tradition, a tradition dating back to the Renaissance in Italy, began to be the subject of ridicule and censure in some circles, in England particularly on the part of William Blake and John Ruskin, but academic teaching had not only been compromised in England. In France, a group of painters known as *les primitifs* had seceded from the studio of the painter Jacques-Louis David. Their astringent tastes prompted the rejection not only of the Renaissance but also of Classical antiquity itself. Secessions had also occurred at academies in Vienna and Munich. In each instance, the weight of academic tradition based upon the Old Masters and underwritten by antiquity had been overturned in favor of a much less dogmatic alternative.

THE ACADEMIES

The Pre-Raphaelite movement in Britain and kindred movements throughout Europe emerged to some extent as a reaction to the teachings of the academies. The idea of an academy, a school devoted to scientific, literary, and philosophical speculation, was revived in Italy by Cosimo de' Medici during the latter part of the fifteenth century and was based upon the model founded by Plato in Athens during the fourth century B.C. The first academy of painting and sculpture, however, emerged during the sixteenth century and sought to raise the disciplines from the realm of humble crafts practised by artisans to intellectually respectable arts that could legitimately rub shoulders with philosophical and literary interests.

THE THEORIES OF ALBERTI

Leon Battista Alberti (1407–72) was one of the first Renaissance scholars to articulate the notion that painting and sculpture were not crafts but activities undertaken with the brain rather than with the hand. Alberti's ideas were of utmost importance and subsequently became a cornerstone of academic teaching. Following the example of such Classical authorities as Aristotle and Horace, Alberti stated in his treatise *Della Pittura* that the purpose of painting, like that of poetry, its sister art, was to represent human nature. It was essential, however, for both the painter and the poet to refine the actions of human beings, to generalize and improve upon nature rather than to depict it exactly as it appeared. The ideal sought by painters and poets, Alberti maintained, was contained not in one exclusive object or person but was dispersed in several. Painting was considered "mute poetry," and it was therefore essential for the painter to ensure that the gestures and

Opposite page: William Blake, Dante and Virgil at the Gates of Hell. *Blake's work was greatly admired by the members of the Pre-Raphaelite Brotherhood.*

Right: Raphael, Parnassus. *Detail showing Dante, Homer, and Virgil. Together with Correggio and Titian, academicians revered Raphael's work .*

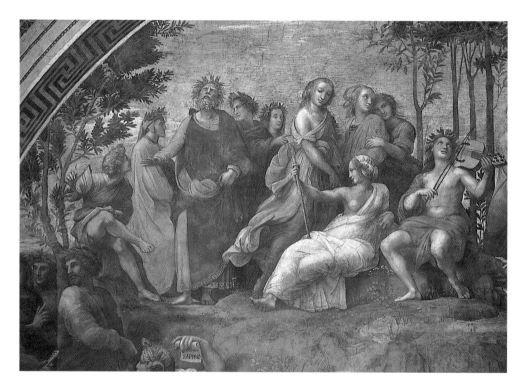

expressions of the human subjects would tell a story with eloquence. Leonardo da Vinci had advised painters to learn this mute form of communication from gestures made by speech-impaired people. At the end of the Renaissance, then, painting had transcended the humble realms of the crafts with which it had traditionally been connected and could now claim to be an art practised by intellectuals and gentlemen.

THE ACADEMIC IDEAL

The precepts outlined in the works of Alberti and Leonardo were developed by subsequent generations and emerged as rigid and at times almost scientific doctrines. The seventeenth-century French preoccupation with rational-ism (the idea that every phenomenon was explicable and conformed to general scientific laws) was applied to all areas of culture and inquiry. Moreover, the influence of the Classical tradition, which had remained strong since the Renaissance, grew as antiquarians began to take a more scholarly interest in the ancient world. The authority of Classical antiquity increased as academic ideals, broadly similar to those enshrined at the Académie Française in Paris, spread throughout Europe. Art historian Nikolaus Pevsner identified 19 academies in Europe by 1720 and well over 100 by the end of the eighteenth century.

Influential studies were written by the art

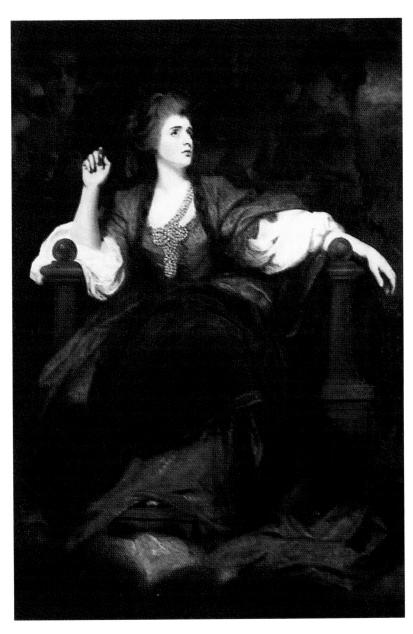

historian Johann Joachim Winckelmann (1717–68) and the painter Anton Raffael Mengs (1728–79). Winckelmann maintained that Classical Greece had not only established a timeless standard of ideal beauty in painting and sculpture, but had founded the ideal on the physical reality of his own race. Winckelmann had a profound influence on both the theories and the practice of his compatriot and friend Mengs, who, not surprisingly, again viewed antiquity (together with the trinity of Raphael, Correggio, and Titian) as providing a timeless artistic standard. The examples of Winckelmann and Mengs were especially important in disseminating academic opinion throughout the remainder of Europe. Mengs played an active part in academies in Rome, Naples, and Dresden and exerted an influence on the curricula for similar bodies in Vienna and Denmark. He was in addition responsible for writing the creed adopted by the Madrid Academy and became the principal of the Accademia in Rome. Friends, pupils, and devotees also played a significant role in the process, and were active in Vienna, Zurich, Leipzig, and Turin.

THE ROYAL ACADEMY

Academic theories evolved in England in a less systematic fashion. A properly constituted academy with support from the crown did not emerge until the end of 1768, when 40 founder-members of the new institution were appointed by George III, with Sir Joshua Reynolds (1723–92) serving as president. The aim of the new Royal Academy was to provide a repository for great examples of

Left: Sir Joshua Reynolds, Portrait of Mrs. Siddons as the Tragic Muse. *Reynolds was the first president of the Royal Academy.*

painting and sculpture in order that the inherent native genius of British painters might be "tamed" by the example of great art. At the shopfloor level, instruction came from Academicians teaching one of a variety of subjects that made up the traditional academic curriculum. Perspective, anatomy, painting, sculpture, and architecture were taught and, following the principle that the highest genre in art is the interpretation of historical and literary subjects, Oliver Goldsmith and Thomas Boswell were also coopted to advise on subject matter.

During the first part of the ninteenth century, the Royal Academy began to accommodate not only paintings in the tried and tested Classical style, but also pictures laden with a heavy sentimentalism. The change had been prompted by the gradual demise of the Whig faction in British social life and the rise of self-made, middle-class men and women. The middle classes had not, on the whole, had access to a Classical education and consequently replaced Greek and Roman mythology with sentimental scenes of everyday life, focusing upon such themes as the home,

motherhood, the virtues of labor, and so on.

The refined tastes that had developed throughout Europe in the wake of hackneyed academicism had been the subject of continual attacks from a variety of factions, and it was in this general climate of revolt that the Pre-Raphaelite Brotherhood emerged. The revolt against academicism predated the foundation of the Pre-Raphaelites by some 50 years and took on various forms. In the nineteenth century, the German *Sturm und Drang* ("Storm and Stress") movement emphasized the importance of individual inspiration and

Right: Franz Pforr,
Knights before a
Charcoal Burner's
Hut. *Pforr and his
fellow Nazarenes
were inspired by the
Middle Ages, and
frequently chose to
depict medieval
themes in their works.*

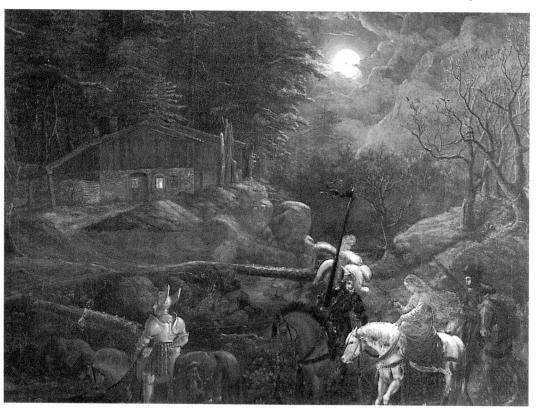

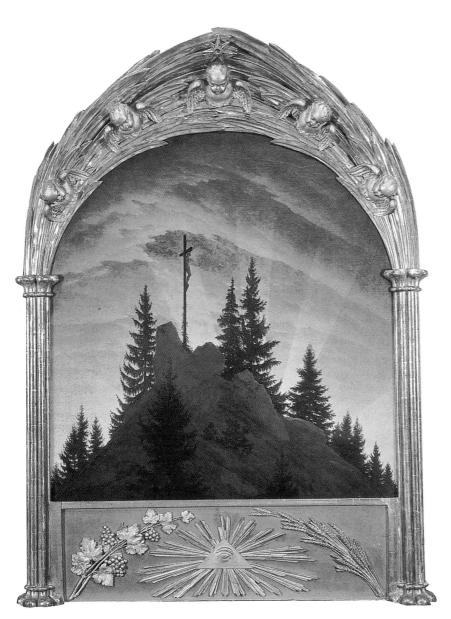

self-expression in painting. Its exponents maintained that the fundamentals of art could not be taught, as the academies upheld, because artistic merit was resident in the artist's imagination rather than in some academic textbook. The career of the Romantic painter Philipp Otto Runge (1777–1810) abandoned an academic training and resorted to a realistic style of landscape painting heavily infused with personal symbolism. A similar symbolism is found in the paintings of Caspar David Friedrich (1774–1840). His pictures, like those of Runge, evince a preoccupation with romantic imagery.

FRENCH ROMANTICISM

Romanticism in France took on a quite different but equally dissident form. Painters such as Théodore Géricault (1791–1824) drew from a repertoire of awesome and often violent images. No less violent were the Shakespearean tragedies which, having been largely ignored for centuries, began to enjoy a vogue in early ninteenth-century Paris. French theater had been dominated by precisely the same preoccupation with rules that had beset painting since the foundation of the Académie Française in 1634. Shakespeare rode roughshod over many of those rules and became something of a Romantic hero for both painters and writers. Further instances can be cited wherein painters (and writers) active in the first half of the nineteenth century began to appreciate the limitations of academic doctrine and thus apply themselves to other solutions. One alternative to the Classical creed which had

Left: Caspar David Friedrich, The Cross in the Mountains, *1808. Most of Friedrich's paintings betray his preoccupation with romantic imagery.*

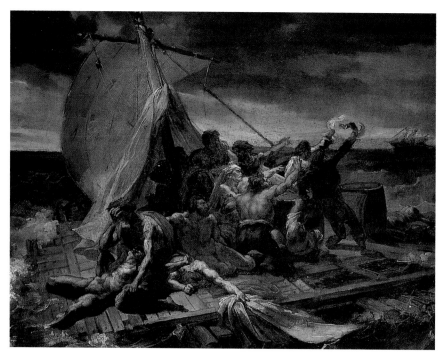

a profound influence on the Pre-Raphaelites was a marked interest in early Christian art.

European academies had consistently been distracted by the examples of Classical and Renaissance cultures, to the extent that medieval painting had often been dismissed as merely "primitive." At the beginning of the 1800s this prejudice began to wane. Wilhelm Heinrich Wackenroeder's essay "Outpourings from the Heart of an Art-loving Priest" was published in 1797. The essays (in the form of a series of anecdotes) stressed that good painting was contingent upon spiritual devotion. The intellectual ideas of Winckelmann and other theorists and artists of the Enlightenment were abandoned in favor of a style of painting that expressed simply piety. Albrecht Dürer (1471–1528), a gifted painter who worked in Germany, was seen as a perfect model. Dürer's best works represented simple, God-fearing people in pictures painted in an equally simple and straightforward, "unlearned" manner. Similar sentiments had been expressed by Wackenroeder's contemporary, the philosopher and critic Friedrich von Schlegel.

An enthusiasm for primitive Italian and northern European painting first found practical form in the work of the *Lukasbrüder*, the Brotherhood of Saint Luke. The Brotherhood was established in 1809 by students who had recently left the academy in Vienna. Dissatisfied by the pedantic academic

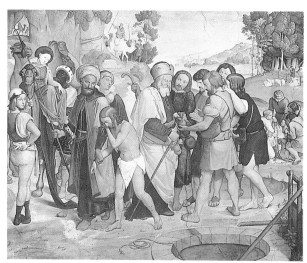

Top left: Théodore Géricault, Study for The Raft of Medusa. *The final work depicting the survivors of the wreck of the* Medusa *was painted in 1819.*

Left: Friedrich Johann Overbeck, Joseph Being Sold by his Brothers, *1816. Overbeck was a member of the Nazarenes.*

curriculum, the group eventually fled Austria and established itself in the disued Benedictine monastery of Sant' Isidoro in Rome. Here Franz Pforr, Johann Friedrich Overbeck, Ludwig Vogel, Johann Konrad Hottinger, Joseph Sutter, and Joseph Wintergerst attempted to revive something of the monastic life artists had led in the Middle Ages. The brethren described themselves as "God's Workmen" and saw their mission as both religious and artistic, the aim of painting being to excite devotion in painter and spectator.

NAZARENE PAINTING

The style of painting produced by the Nazarenes, as they later called themselves, varies. Some paintings evoke a naturalistic style popular in Germany and the Low Countries during the fifteenth and sixteenth centuries, while others depend heavily upon early Italian influence. Some pictures even employ a muddled perspective common in early Quattrocento paintings; others emulate the serenity of Raphael. Furthermore, the brothers drew not with the broad, soft chalks used by the Old Masters and, by extension, the drawing classes at the academy, but used hard, sharp pencils that gave the artist an opportunity to depict subjects in meticulous detail.

Although the Brotherhood of Saint Luke lost much of its original impetus, its example did have a strong influence on British painting during the 1830s and 1840s, thus preparing the ground for the Pre-Raphaelites. English culture nursed an interest in medieval art and architecture from the middle of the eigteenth

Above: Peter von Cornelius, The Last Judgement. *A Nazarene, von Cornelius was noted for his detailed work.*

Left: Peter von Cornelius: The Wise and Foolish Virgins.

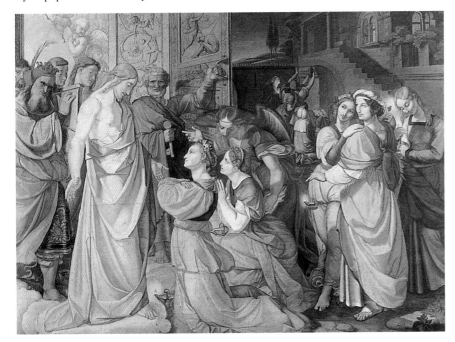

century, and this penchant began to increase drastically in the nineteenth century. Prince Albert was an active patron of the arts. As a German prince, he had a patriotic affinity for a Teutonic or northern European Gothic style. The authority of this already popular style increased immeasurably when it was chosen as the appropriate idiom for Sir Charles Barry's new Houses of Parliament (designed with the assistance of Augustus Welby Northmore Pugin) in 1839. A royal commission, under the direction of Prince Albert, supervized the decoration of the palace, ordering a series of frescoes for the interior. The choice of fresco (painting with pigments onto wet plaster) as the favored medium is significant, for it was common in the Middle Ages and Renaissance but virtually extinct in nineteenth-century Britain. However, consistent with the vogue for medieval art and architecture, it was revived as a fitting manner with which to decorate Barry's Gothic palace.

THE FOUNDING OF THE PRE-RAPHAELITES

In Britain, the Pre-Raphaelite Brotherhood was founded in London in the fall of 1848, adopting its name in deference to the painters working before the time of Raphael. This secret society had been convened by Dante Gabriel Rossetti, William Holman Hunt, and John Everett Millais, and was extended to include four others: the painters James Collinson and F. G. Stephens; the sculptor Thomas Woolner; and William Michael Rossetti, the brother of Dante Gabriel and a tax clerk who would act as diarist and secretary to the Pre-Raphaelite circle.

The aim of the seven was an ambitious one: to reform the standards of English painting, which in the Victorian era had sunk to lamentably mediocre level. Enshrined within the

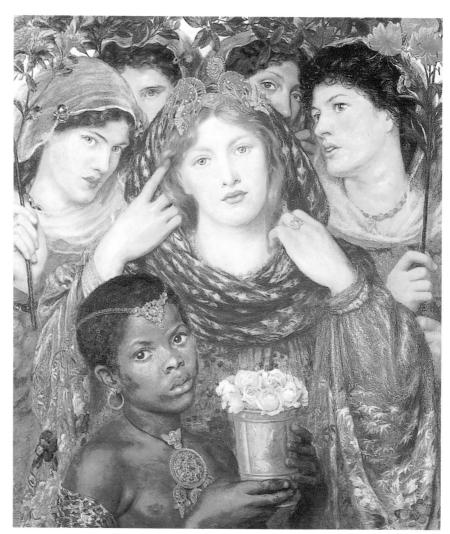

Above: Dante Gabriel Rossetti, The Beloved, *1865–66. Much of Rossetti's later work was characterized by the abstract sentimentality of his allegorical and devotional portraits of women.*

Royal Academy, a bastion of conservative artistic taste, was a style and method of painting originally invented in sixteenth-century Italy and still being applied centuries later in some quarters. In the hands of Raphael and his successors this refined style, which was to become the cornerstone of academic teaching throughout Europe and beyond, had produced some of the most breathtakingly beautiful and articulate work of the High Renaissance. However, in the hands of British artists active in the first decade of Victoria's reign, the same academic tradition had produced a corpus of dull and often embarrassing pictures. It was in the context of this lackluster milieu that the Pre-Raphaelite Brotherhood challenged not only the Victorian artistic establishment and the entire weight of academic tradition, but also the example of the "Divine" Raphael himself.

THE PRE-RAPHAELITE ETHOS
The Pre-Raphaelite convenant required that, far from following the example of a Renaissance rubric epitomized by the work of Raphael and a pantheon of Old Masters, painting should return to the pious, naturalistic, and unaffected approach found in the work of artists active during the fourteenth and fifteenth centuries (and, even more importantly, turn to nature itself). Between 1848 and 1849, often with more zeal than ability, the Brotherhood produced a handful of brightly colored and minutely detailed pictures, depicting unconventional subjects culled from the Bible or medieval poetry and imitating both

Left: Fra Angelico, The Coronation of the Virgin. *Fra Angelico's work was admired by the Pre-Raphaelites, although some Victorian connoisseurs thought it primitive.*

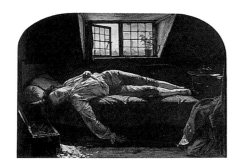

Above: Henry Wallis, The Death of Chatterton, *1856. This work was one of a series of literary themes undertaken by the artist.*

Below: Sir Edward Coley Burne-Jones, The Mill, *1870. The artist's later subjects had an ethereal, otherworldly, quality.*

the style and form of fourteenth- and fifteenth-century art. Each picture bore the secret mark of the Brotherhood's devotion to pictorial reform: the initials "P.R.B."

THE PRE-RAPHAELITES SET IN CONTEXT

The aims of the Pre-Raphaelites, despite the eagerness with which the brethren sought to reform English art, were hardly new, and close scrutiny shows that the immature artists who formed the Brotherhood in 1848 were ill-aware of the intellectual position they occupied on the European cultural stage.

The Pre-Raphaelite Brotherhood was, at its inception, generally unaware that its program of reform placed its members in exceptionally good company, for many others had also taken flight from the sophistication of the present to find comfort in the primitive traditions of the distant past. The members of

the Pre-Raphaelite Brotherhood were thus not only unable to see themselves as part of a more widespread pattern of dissent, but, apart from some broad and generalizing principles, such as an antipathy for academic dogma, an admiration for early Italian painting highterto dismissed by many connoisseurs, and the belief that painters should have "no master except their own powers of mind and hand, and their own first-hand study of Nature," the aims of the Pre-Raphaelite Brotherhood can often be described as somewhat vague, ill-articulated and inconsistent.

The notion of a Pre-Raphaelite "movement" then, compared to the movements that dominate twentieth-century art, is something of a fiction. Pre-Raphaelitism in all its forms can only be understood in terms of the wider, more consistent, and more articulate artistic and intellectual climate of the period.

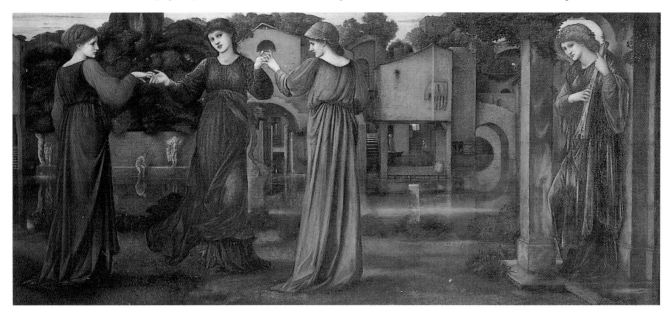

THE EARLY YEARS OF PRE-RAPHAELITISM

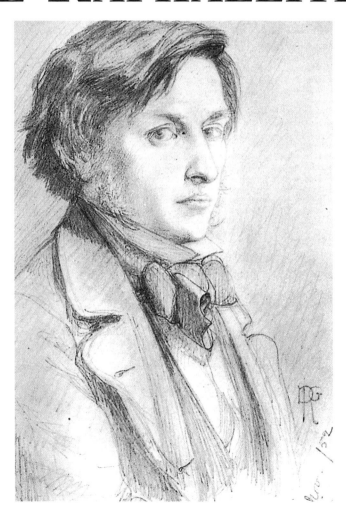

Preceding page: Dante Gabriel Rossetti, Pencil Portrait of Ford Madox Brown, *1852. Brown was Rossetti's tutor.*

Several painters associated with the Brotherhood claimed to have invented the label "Pre-Raphaelite." Students at the Royal Academy had, apparently, used the term as a pejorative description of the early Italian art so admired by Millais and Hunt. There is evidence, however, that the term "Pre-Raphaelite" had some currency well before 1848, although Millais and Hunt both claimed responsibility for the name. Writing in *Pre-Raphaelitism and the Pre-Raphaelite Brotherhood*, published in 1905, Hunt claimed that it was he who recommended the use of the term "Pre-Raphaelite" in preference to "Early Christian."

Below: Giotto, Death of the Virgin. *Antiacademicians, including the Pre-Raphaelites and Ruskin, admired the naturalistic piety of such paintings.*

Founded in London in September 1848, the Pre-Raphaelite Brotherhood was initially a secret society. The seven founder-members were Dante Gabriel Rossetti (1828–82), John Everett Millais (1829–96), William Holman Hunt (1827–1910), James Collinson (1825–81), F. G. Stephens (1828–1907), Thomas Woolner (1825–92), the only sculptor among the group, and William Michael Rossetti (1829–1919), a tax clerk by trade and the Brotherhood's secretary. The painter Ford Madox Brown (1821–93) was an active and influential "fellow-traveler," but never became a formal member of the Brotherhood.

The group's name was the subject of long discussion between its members. The term "Early Christian" would have had some unfortunate pro-Catholic connotations in mid-nineteenth-century England, and would have evoked some of the bitter disputes between the Church of England and Tractarian factions centered around Oxford. Rossetti was responsible for appending the term "Pre-Raphaelite" to the word "Brotherhood," thus

affording the society something of a conspiratorial and monastic air.

The aims of the group are not easily summarized. Millais, Rossetti, and Hunt, who were the Brotherhood's dominant figures, were aged 19, 20, and 21 respectively in 1848, and would have had only a fragmentary grasp of the Romantic current of thought that had emerged in opposition to academic convention. And only Ford Madox Brown among the Pre-Raphaelite circle had had first-hand experience of early Italian painting.

THE PRE-RAPHAELITE CREDO

It is not surprising, then, to discover that the Brotherhood's credo was immature and at times confused. All three painters had been students at the Royal Academy and were bound

Above: James Collinson, St. Elizabeth of Hungary, c. 1848–50. Collinson was a founder-member of the Pre-Raphaelite Brotherhood in 1848.

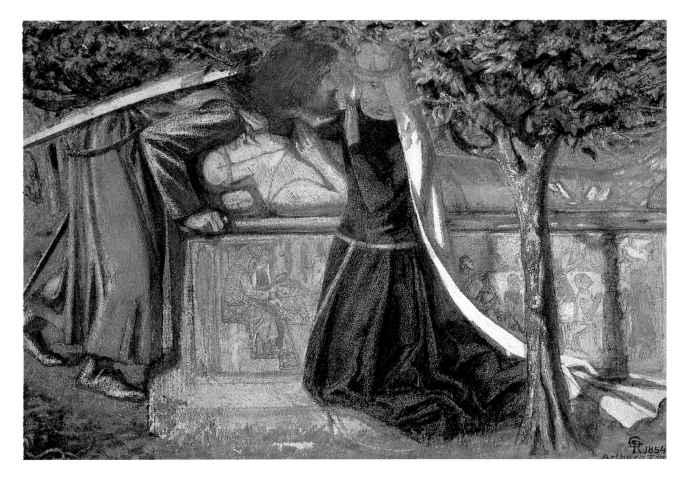

Above: Dante Gabriel Rossetti, Arthur's Tomb, 1854. *The theme of medieval romance dominated the circle's early work.*

primarily by a strong antipathy towards its institutionalized approach and an equally strong enthusiasm for art that rode roughshod over conventional taste. William Blake and William Hogarth, both of whom had flouted academic convention, were admired by the circle, although it was early Italian and Flemish painting that had a special place in the Brotherhood's collective heart.

The earliest paintings associated with the Pre-Raphaelite circle used themes from medieval literature or the Bible. It is curious to discover, however, that members of the Brotherhood constantly stressed the importance of naturalism in painting. William Michael Rossetti attempted to summarize the aims of the Brotherhood and required only that the painting be purged of rules; the logical formulae that had dogged the arts for centuries were to be abandoned for a canon that

prescribed only nature's example and the artist's untutored intuition. These sentiments had been endorsed by Hunt. He had stressed the importance of nature as the prime source of reference for painters, and had roundly condemned the "lethal" influences of such academicians as Le Brun, Mengs, and Reynolds.

The Pre-Raphaelite concept of naturalism requires careful qualification. The movement, at least in its earliest stages, declined to represent the real, immanent world of the mid-nineteenth century, and its paintings are quite distinct from the naturalistic paintings being produced in France by such artists as Gustave Courbet. Rather, the Pre-Raphaelites insisted that painters of the fourteenth and fifteenth centuries were unsophisticated craftsmen. Motivated only by simple piety, and unburdened by the theoretical trappings of later generations of painters, artists of the Trecento and Quattrocento periods were able to work with a direct and heartfelt simplicity and thereby to represent the world in an uncomplicated, straightforward style.

ARCHAISM AND NATURALISM

Pre-Raphaelite painters and their associates followed this example. They used medieval or biblical subject matter, but treated their themes with a marked sense of unsophisticated naturalism, wherein scenes from the past were depicted as real, historical events. Pre-Raphaelite paintings were often prepared only after a good deal of historical research into the customs, dress, furniture, and accessories of the period. In fact, it was this same desire for verisimilitude in painting that eventually led Hunt to visit the Holy Land and to paint religious pictures in the very environment in which the scenes were historically supposed to have taken place.

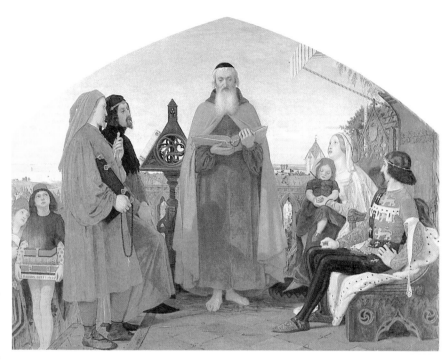

The blend of archaism and naturalism that characterized many of the earliest Pre-Raphaelite pictures had been used by Ford Madox Brown several years before the foundation of the Brotherhood. In 1845 Brown began a work entitled *The Seeds and Fruits of English Poetry*. The picture, made in a form approximating that of an early Italian triptych, shows Chaucer reading his poetry to Edward, the Black Prince, surrounded by courtiers and flanked by a pantheon of British poets from all historical periods. Although the subject is almost absurdly contrived and reminiscent of the nationalistic fervor found in some eighteenth-century art and architecture, the style of painting is nonetheless naturalistic. The bituminous coloring and theatrical composition found in some conventional paintings are

Above: Ford Madox Brown, Wycliffe Reading his Translation of the New Testament to his Protector, John of Gaunt, c. *1847–48.*

exchanged for a brightly colored and meticulously detailed arrangement of figures who are informally huddled around the central figure of Chaucer.

A similar sense of naturalism is found in Madox Brown's picture *Wycliffe Reading his Translation of the New Testament to his Protector, John of Gaunt*, painted in the winter of 1847 to 1848. The picture shows Wycliffe centrally positioned under a segmented arch, flanked by Chaucer and Gower on the left and John of Gaunt and the Duchess of Lancaster on the right. In the left- and right-hand corners of the picture are two allegorical figures representing the Protestant and Roman Catholic faiths. Although the painting is, again, contrived, and betrays a debt to the Nazarenes, naturalism (albeit in an unusual form) is much in evidence. All the figures within the picture were modeled by friends and associates of the artist. Madox Brown's sense of naturalism also extends to the furniture and costumes; Henry Shaw's recently published *Specimens of Ancient Architecture and Dresses and Decorations of the Middle Ages* were consulted to ensure that the costume and furniture within the picture were historically appropriate to the period.

THE FIRST PRE-RAPHAELITE WORKS

Madox Brown was a tutor to Rossetti and mentor to the Pre-Raphaelite Brotherhood, and his works betray many of the characteristics that are found in Pre-Raphaelite painting. But the first genuinely Pre-Raphaelite works were executed in the fall and winter of 1848 to 1849. They were by Rossetti, Millais and Hunt, and they bore the enigmatic inscription "P.R.B." The pictures were Millais's *Isabella*, Hunt's *Rienzi Vowing to Obtain Justice for the Death of his Younger Brother,* and Rossetti's *The*

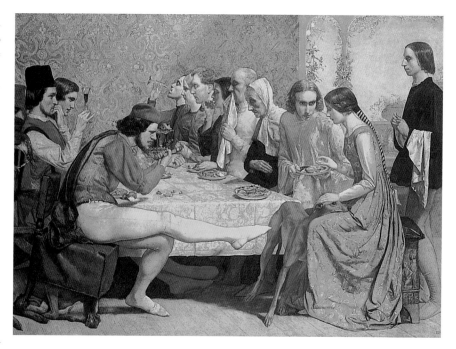

Girlhood of Mary Virgin. They have much in common and are quite distinct from some of the works by the same painters that immediately predate the formation of the Brotherhood.

Millais's *Isabella* depicts a violent theme adapted by Keats from Boccaccio's *Decameron*, in which an ill-fated love affair between Isabella and Lorenzo ends in tragedy. Lorenzo, a servant in Isabella's household, was considered a poor match by her brothers and was promptly murdered. His ghost revealed the murder to Isabella who exhumed the body, severed the head and hid the memento in a pot of basil. The head was discovered and taken by Isabella's brothers, and Isabella herself eventually died of a broken heart. Millais's picture is painted in bright colors and drawn with meticulous attention to detail. Moreover,

Above: Sir John Everett Millais, Isabella, *1848–49. The picture carries the inscription P.R.B. on the base of Isabella's chair. There is a curious absence of linear perspective in the painting; all the figures are of the same size.*

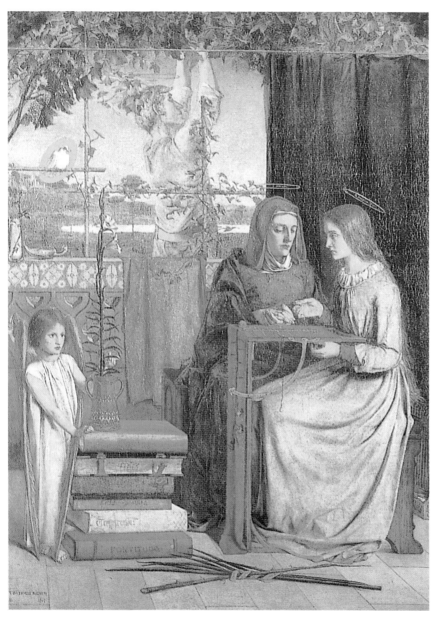

it is organized in a very unconventional manner, quite unlike the affected composition of *Cymon and Iphigenia*, painted the previous year. The figures are arranged around a table that sharply recedes into the distance. There is a curious absence of linear perspective in the painting; close inspection shows that all the figures are the same size, irrespective of their distance from the spectator. A contemporary critic, writing of *Isabella* in the *Literary Gazette*, recognized this characteristic and thought the absence of conventional perspective an impressive imitation of an "Early Italian" manner.

Millais's *Isabella*, like the majority of early Pre-Raphaelite works, contains a strong narrative which is emphasized by objects or symbols that refer to some larger aspect of the literary source. Lorenzo passes Isabella a blood-orange served from a plate decorated with a scene from either the story of David and Goliath or that of Judith and Holofernes, both of which involve decapitation. On the balustrade in the background of the picture stands an ominous pot of basil, beside which two passion flowers are entwined.

ROSSETTI'S USE OF SYMBOLISM

A similar interest in prefigurative symbolism appears in Dante Gabriel Rossetti's first Pre-Raphaelite painting, *The Girlhood of Mary Virgin*. The picture, like *Isabella*, forsakes conventional perspective. Rossetti apparently found the subject tiresome, and his seeming lack of application is evident in the way in which the figures are, again, identical in

Left: Dante Gabriel Rossetti, The Girlhood of Mary Virgin, *1848–49. Rossetti's image of the adolescent Virgin Mary was the first of his pictures to be labeled "P.R.B."*

size, irrespective of their position in the picture. Still, the painting is passably naturalistic, showing an adolescent Mary working at a piece of embroidery (Rossetti himself stated that the pastime would have been a likely one for young women of the period). Surrounding Rossetti's "symbol of female excellence" are devices that prefigure the Virgin's fate. The angel clasps a lily, a symbol of purity, which is to be presented at the Annunciation. The dove on the trellis represents the Holy Ghost, the lamp stands for piety, and the vine bears fruit which, made into wine, symbolizes the sacrament of the Eucharist.

It is worth remembering that the subjects of many Pre-Raphaelite pictures were quite original and that their often arcane symbolism would have eluded most spectators. In this instance, Rossetti explained the meaning of the components in the picture by means of a sonnet inscribed on the original picture frame.

CRITICAL ACCLAIM

The Brotherhood was initially encouraged by the way in which its first works had been received. The journal the *Athenaeum* had sniped at Millais's unconventional *Christ in the House of his Parents* and complained, quite astutely it seems, that the work defied the accepted canon of beauty. Other critics, however, were more appreciative. Rossetti's *The Girlhood of Mary Virgin* received critical acclaim from many quarters and was bought by the Marchioness of Bath for the then not inconsiderable sum of 80 guineas. Millais's *Isabella* sold for almost twice that amount and Bulwer Lytton, whose novel *Rienzi, the Last of the Tribunes*, had formed the basis for Hunt's first Pre-Raphaelite work, wrote to the artist to express his deep admiration for the picture.

THE GERM

It was a growing sense of confidence brought on by such critical acclaim that led the Brotherhood to expand and articulate both its literary and artistic aims in the form of a magazine, first published in 1850 and entitled *The Germ*. The literary aspirations of the circle were summarized by William Michael Rossetti. Poetry should, he maintained, be the result of the honest and personal convictions of the writer rather than determined by literary convention. The advice is, in fact, the equivalent of that given to

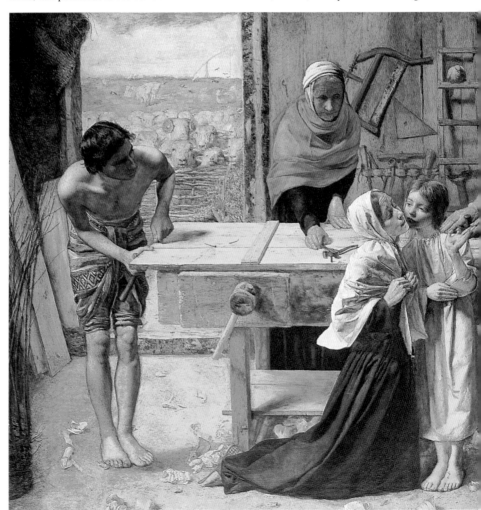

Below: Sir John Everett Millais, Christ in the House of his Parents, *1849–50. The scene from Christ's childhood was inspired by Rossetti's* The Girlhood of Mary Virgin, *painted during the previous year.*

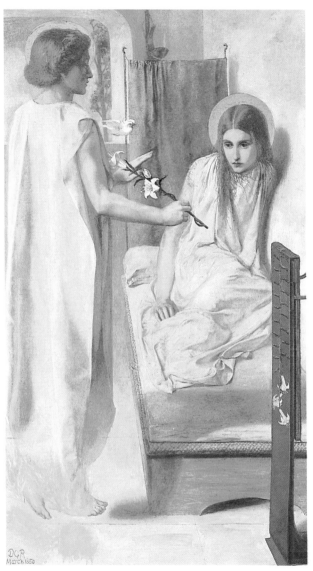

Above: Dante Gabriel Rossetti, Ecce Ancilla Domini! *1849–50. This was first exhibited at the National Institution in 1850.*

Right: William Holman Hunt, A Converted British Family Sheltering a Christian Missionary from the Persecution of the Druids, *1850. Hunt's work, although naturalistic, had a moral message.*

painters, yet, despite Rossetti's dictum, it is difficult to discern any literary or theoretical party line within *The Germ..* F. G. Stephens, for example, under the pseudonym of Laura Savage, wrote an apologia for early Italian art and a curious defense of contemporary, industrial subject matter. John Lucas Tupper shared Stephens's (or rather, Savage's) interest in contemporary themes in painting, whereas John Orchard insisted that painting should be the vehicle for religious sentiment.

The Germ, which ran to only four editions, also contained contributions from William Bell Scott, Ford Madox Brown, Coventry Patmore, Walter Howell Deverell, Christina Rossetti, and others. It did much to swell the ranks of the Brotherhood beyond its initial secret seven.

In the summer of 1850 the press and the public at large began to learn of the existence of the hitherto covert movement, and critical reactions to the circle began to take on a distinctly hostile turn. Several Pre-Raphaelite pictures exhibited at the Royal Academy and at the Free exhibitions in 1850 and 1851 were subjected to bitter critical comment. Millais's *Christ in the House of his Parents* was savagely attacked by Charles Dickens in *Household Words* of 1850. Dickens described the figure of Christ as "a hideous, wry-necked, blubbering, red-haired boy in a nightgown" and his mother as "so horrible in her ugliness that . . . she would stand out from the rest of the company as a monster in the vilest cabaret in France or the lowest gin-shop in England."

RELIGIOUS CROSSCURRENTS

It is important to recognize that the critical attention given to the Pre-Raphaelite works exhibited in the early 1850s was often motivated not only by artistic doubts about the revival of the archaic conventions of fourteenth- and fifteenth-century painting, but also by the covert nature of the Brotherhood and some of the curious religious affinities found in its works. Since the beginning of the 1830s, a militant High Church sect within the Church of England had made a concerted attempt to revive some of the rituals and traditions of the early Church. To some extent this revivial was a logical extension of the Romantic revivalism that had touched architecture, literature, social reform, and painting and sculpture. Some

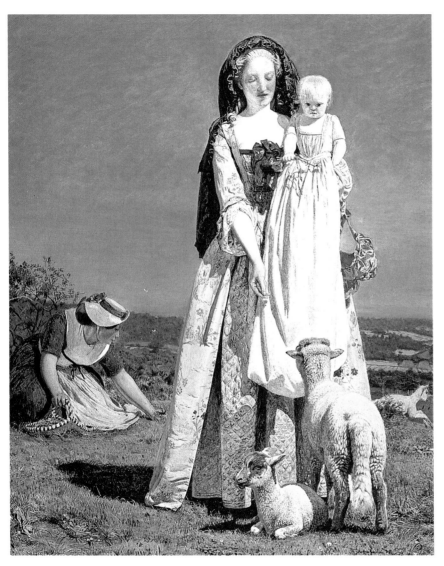

preachers and theologians, however, had revived ritual as a counter to what they regarded as the spiritually vacuous service of the liberal Church establishment, and had therefore moved increasingly close to the conventions of the Roman Catholic religion. The increasingly embittered debate between these High Church, or Tractarian, factions and the liberal establishment was exacerbated when militant Low Church Evangelists added their weight to the dispute. Thereafter, attitudes began to polarize.

CATHOLIC CONCERNS

Conversions to Rome on the part of both clergy and laymen increased and soon became the source of some public anxiety. What had once been a limited dispute among academics and theologians had developed into a source of great public concern, with political ramifications on the traditional bond between Church and State in England. Public attention was so attuned to these issues that a religious picture with anything other than the most innocuous and conventional imagery would have immediately been seen to identify with one faction or another.

It was in this context that some critics believed that they had spotted a covert and potentially dangerous Mariolatry within Ford Madox Brown's *The Pretty Baa-Lambs*, first exhibited at the Royal Academy in 1851. The painting, in fact, showed only a young woman with a child in her arms standing in the open air on a brilliant, sunlit day feeding sheep. Some years later, Madox Brown was to set the record straight, explaining that "a deep philosophical intention" was not his aim, and that the painting was merely one depicting "a lady, a baby, two lambs, a servant maid, and some grass."

Above: Ford Madox Brown, The Pretty Baa-Lambs *(detail). Some critics thought that the painting reeked of Mariolatry.*

JOHN RUSKIN

The critical attention generated by the Pre-Raphaelite paintings of the early 1850s became important to the subsequent development of the circle. Attacks in the press prompted Coventy Patmore to seek the help of John Ruskin who came, albeit somewhat guardedly, to the Brotherhood's defense. Ruskin disassociated himself from its rather ill-chosen and contentious name, and from any High Church leanings within the Brotherhood's *oeuvre*, but staunchly defended its heightened sense of naturalism. Ruskin qualified his support in a series of letters to *The Times*, the first of which appeared in May 1851. He defended the circle's pictures against specious accusations of an obsessive attention to often superfluous detail and to charges of a self-conscious archaism and poor perspective.

Ruskin countered that the Pre-Raphaelite technique of illuminating the whole picture rather than simply its most significant parts was entirely consistent with the phenomenon of natural sunlight which, he claimed, had marginally greater authority than academic convention. The Pre-Raphaelites had, in fact, evolved a particular technique for achieving this effect of sunlit color in their works. The technique, which Millais wanted to keep secret, involved the application of a thin layer of wet, white oil paint on the surface of the canvas, over which transparent layers of color were added with a sable watercolor brush. When applied with sufficient care, the white paint would shine through, rather than mix with, the pigment, affording the color a particular brilliance.

Ruskin further argued that the perspective within Pre-Raphaelite pictures was not especially at fault, and that he could find far greater errors in any 12 academic pictures chosen at random. The works of the Pre-Raphaelites were, moreover, archaic only in that they shared the same fidelity to nature as painters of the fourteenth and fifteenth centuries. The paintings were, he insisted, "more earnest and complete in their aspirations than anything painted since the time of Dürer" and he suggested that the Brotherhood's efforts would eventually establish a school of art nobler than anything seen in the past three hundred years.

Ruskin's support was an enormous boost for the Brotherhood and, through the medium of his correspondence (a pamphlet on the aims of the movement and subsequent editions of *Modern Painters*), he served to clarify the Pre-Raphaelite cause and associate it

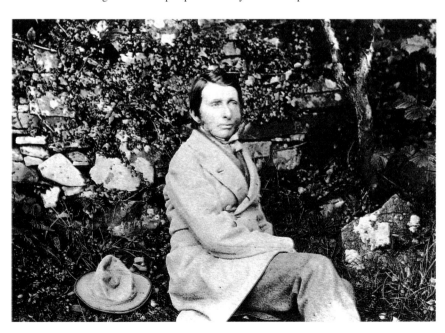

Right: A photograph of John Ruskin, the critic who defended the Pre-Raphaelites and whose support was a great boost.

with an ever more assiduous attention to naturalism. The period between 1851 and 1854 was to a large extent the "high noon" of Pre-Raphaelitism and saw the production of some impressive essays on naturalism, particularly on the part of John Everett Millais.

NATURALISM IN THE WORK OF MILLAIS
In 1852 Millais painted a picture inspired by the fourth act of *Hamlet,* in which Ophelia, driven mad by her lover's feigned insanity and the death of her father, casts herself into a stream. The picture contains an unprecedented attention to botanical detail. The figure of Ophelia, modeled by Elizabeth Siddal (posing in a tub of tepid water), is surrounded by plant life, much of which has a symbolic allusion in the text of Shakespeare's play. In 1852 the painting also contained a bunch of daffodils, although Tennyson pointed out that the presence of spring flowers was inconsistent with the other summer flora in the picture and Millais, for verisimilitude's sake, removed them. The naturalistic aspirations of Millais and Ruskin met more directly, however, in the artist's portrait of the critic, painted while the two were on holiday at Glenfinlas in Scotland. The picture shows a contemplative Ruskin standing on some magnificently detailed rocks beside a torrent, and thus also reflects the critic's profound interest in natural science.

Above: Arthur Hughes, Ophelia, *1852. This was one of several works exhibited by the artist in the United States.*

Millais began to receive critical acclaim for many of his pictures, and was elected an associate member of the Royal Academy in 1853.

The works of Hunt and Rossetti had taken a different turn, however. Hunt's paintings, although intensely naturalistic, were increasingly laden with moral or religious messages. Some moral predicate had been an important part of the Pre-Raphaelite credo in 1848, and although the individual interests of the brethren had broadened, Hunt believed that his work remained true to their original spirit. *The*

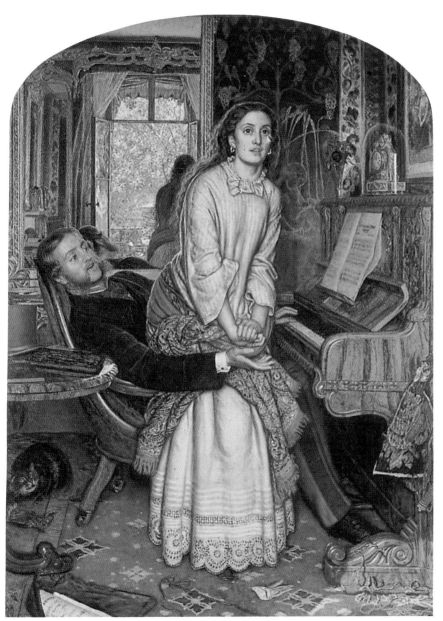

Awakening Conscience and its pendentive, *The Light of the World*, serve as two good examples of Hunt's secular and spiritual interests in painting. The former picture shows a young, half-dressed (in Victorian terms) woman, rising from the lap of her lover toward an open window, which is reflected in the mirror in the background of the picture. She is shown at the precise moment of her conversion from a dissolute and wanton existence to a state of redemption, symbolized by a shaft of light on the right of the picture. Other components in the painting allude to the woman's plight: a cat is about to pounce on a bird under the table on the left of the picture; on the right is a glove cast off in a way that could prefigure her own fate. The two pieces of sheet music on the piano and floor are, respectively, Thomas Moore's "Oft in the Stilly Night" and Edward Lear's "Tears, Idle Tears," both of which refer, appropriately, to lost innocence. *The Light of the World* shows spiritual redemption in contrast to wordly sin, as epitomized in the popular Victorian image of the fallen woman. Ruskin explained the symbolism in the picture (which appears to have gone completely over the heads of most spectators) in a letter to *The Times*. The disused and overgrown door on which Christ knocks is a symbol of the human soul ignorant or impervious to Christ's teaching, and the light from his lantern embodies conscience on the one hand and salvation on the other.

THE MYSTICAL WORKS OF ROSSETTI

Meanwhile, Rossetti's paintings had assumed a form quite alien to those of his Pre-Raphaelite

Left: William Holman Hunt, The Awakening Conscience. *This painting represents a symbolic allusion to lost innocence.*

contemporaries. Paintings such as Hunt's *The Hireling Shepherd*, Madox Brown's *The Last of England*, Deverell's *The Irish Vagrants*, and Millais's *Huguenot, on St. Bartholomew's Day* had taken on a cross-section of social, religious and literary themes, although all had been expressed with a keen sense of naturalism. Rossetti, however, had not publicly exhibited a picture since 1850, and had evolved a personal and mystical symbolism inspired by chivalric themes and medieval poetry. His interest in mysticism was complemented by a curiously ethereal space in his pictures, at times often reminiscent of the watercolors and drawings of William Blake, whom Rossetti greatly admired. Evidence of Rossetti's quite unnaturalistic use of space had been evident in his *Ecce Ancilla Domini!* In *The First Anniversary of the Death of Beatrice*, painted between 1853 and 1854, Rossetti shows Dante interrupted by three friends who come upon him while he is drawing an angel to commemorate the death of his beloved Beatrice. Rossetti depicts a well-observed room (modeled upon a Flemish rather than a Florentine interior), with a view across the Arno; the figures are again based on friends, family, and associates. The final result, however, is far removed from the naturalism of his contemporaries, with its vivid local colors and its very unconvincing picture space. Rossetti was to repeat the theme of Dante and Beatrice on many occasions, particularly after the death of his wife, Elizabeth Siddal, from which point Dante's relationship with Beatrice became an especially deeply felt metaphor for the artist's own exclusive and obsessive marriage.

By about 1854 the Pre-Raphaelite Brotherhood had lost much of its original momentum and purpose. Millais had argued for its dissolution on the grounds that the group's members were no longer united by a common bond. The Brotherhood had always been fueled by enthusiasm rather than by some common purpose, and its members' disparate aims were becoming acutely apparent by the mid–1850s. Individual members had also begun to abandon the Brotherhood. Thomas Woolmer, for instance, had left to prospect for gold in America as early as 1852, and James Collinson departed the following year to train for Holy Orders in a Jesuit monastery. Hunt,

moreover, left for Egypt in January 1854 and Millais, having received official recognition from the Royal Academy, had thereby somewhat lost his previous credibility as an artistic dissident.

THE LATER YEARS OF PRE-RAPHAELITISM

Although the formally constituted Brotherhood had all but vanished, a loose confederation of painters, centered around some of the founder-members of the Pre-Raphaelite circle, did much

Above: Ford Madox Brown, The Last of England, *1852–55. This painting, on the theme of middle-class emigration, was inspired by Thomas Woolner's departure for America in 1852.*

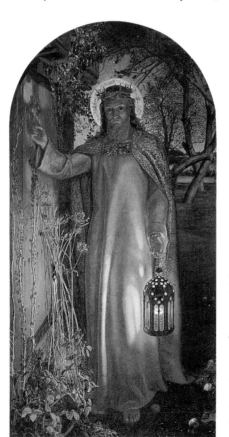

Left: William Holman Hunt, The Light of the World, *1851–53. The frame carries an extract from Revelation 3:20, "Behold, I stand at the door." The light carried by Christ embodies conscience and salvation.*

to develop and articulate some of its ill-defined interests. It is to them, and especially to the towering figure of John Ruskin, that one has to look to trace the subsequent development of Pre-Raphaelitism.

Below: Dante Gabriel Rossetti, Dante's Dream, *1856. The subject, taken from the* Vita Nuova, *depicts the author's dream of Beatrice's death.*

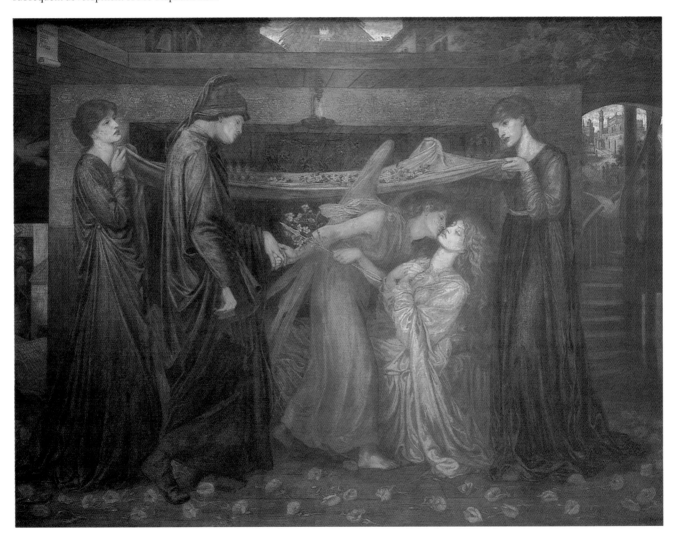

The Pre-Raphaelite Movement During the 1850s and 1860s

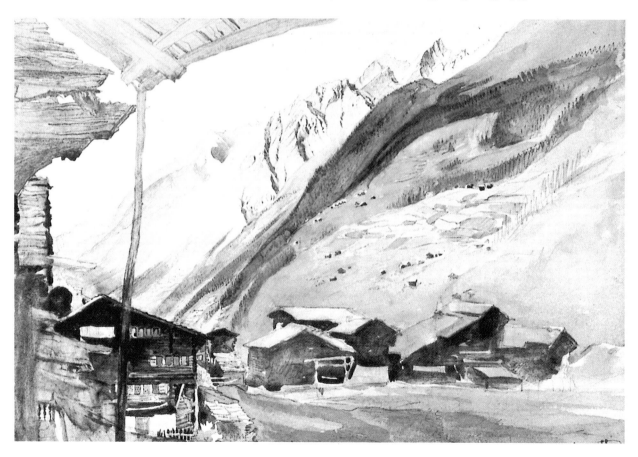

In a letter of 1868, Dante Gabriel Rossetti stated that John Ruskin had not established the Pre-Raphaelite school, as many people believed. Rossetti's interpretation of Ruskin's role is historically quite accurate: the Pre-Raphaelites evolved, at least during the first few years, quite independently of Ruskin's influence, and he and they only discovered some common purpose after the critic's intercession on behalf of the Brotherhood in 1851.

Preceding page: John Ruskin, Zermatt, Switzerland, *watercolor.*

The figure of John Ruskin is, however, of seminal importance to the unfolding aims of the Pre-Raphaelite circle. His work did much to clarify and articulate some of the Brotherhood's often ill-defined ambitions and provided historical and theoretical reference points, not only for the Pre-Raphaelites but also for many other nineteenth-century artists, architects, and craftsmen active throughout Europe and the United States.

Below: John Ruskin, The Matterhorn seen from the Moat of the Riffelhorn, *1849. An unaffected depiction of the natural world was a consistent feature of Ruskin's work.*

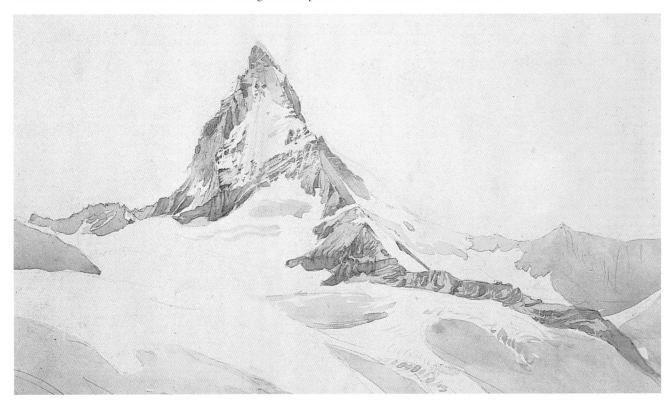

Born in 1819, Ruskin was educated at Christ Church, Oxford University, having already gained an early appreciation of art and architecture through his father. The family traveled extensively throughout Europe during Ruskin's youth, visiting collections of art. Even at this early stage the young man betrayed a marked distaste for Italian Renaissance culture, and appears to have found far greater appeal in the Alpine scenes that had inspired picturesque landscape painters during the early part of the nineteenth century. An affinity with the unaffected depiction of the natural world was to emerge as a consistent feature of Ruskin's work and an important standard for the assessment of the work of others.

MODERN PAINTERS

Ruskin's first work outlining his ideas on naturalism in painting found form in the first volume of the monumental *Modern Painters: Their Superiority in the Art of Landscape Painting to the Ancient Masters*, published in 1843. Ruskin had planned to write a heroic defense of modern landscape painting with a particular emphasis on the work of Turner, as a riposte to the philistinism of the British press, which had made a series of puerile slights against this venerable figure. Landscape painting is a language, Ruskin insisted. Its overriding aim is the representation of natural facts. It is important to remember that whenever Ruskin referred to nature and an artist's ability to record it accurately he was invariably alluding to something much greater than the

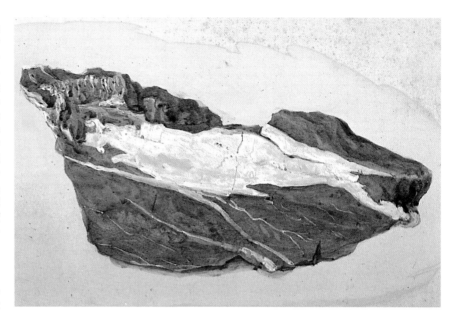

Top right: John Ruskin, Watercolor Study of Rock Fragment with Quartz Vein.

Right: Joseph Mallord William Turner, Burning of the Houses of Parliament, *1835.*

Right: Joseph Mallord William Turner, Agrippina Landing with the Ashes of Germanicus, *1839. Ruskin believed that Turner's pictures demonstrated his understanding of the natural world.*

Below: Joseph Mallord William Turner, Venice, Calm and Sunrise, *1842–43.*

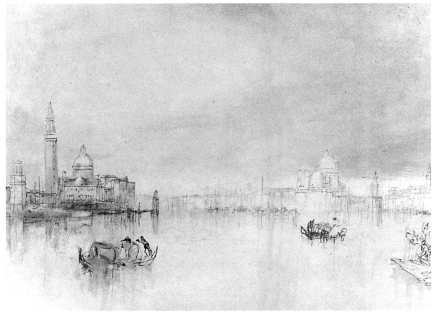

inanimate stuff of the outside world. For Ruskin, nature had a divine origin and was invested with a profound sense of gravitas; it was subject to change and growth, and took on a character which could be benign and tranquil at one end of the scale and malign and ferocious at the other. Painters such as those of the Dutch School, who aspired to paint nature's physical form at the expense of its spiritual, were, for Ruskin, of limited capacity. Turner's pictures, he maintained, demonstrated a deep understanding of the natural, factual world to which he referred so frequently, although these facts are rendered with a sense of gravitas which transcended literal visual experience. Turner, for Ruskin, represented not the prosaic details of the sea, mountains, and sky, but their very depth, movement, height and volume. In fact, so profound was Turner's understanding of the poetic qualities of natural phenomena that his superior authority had

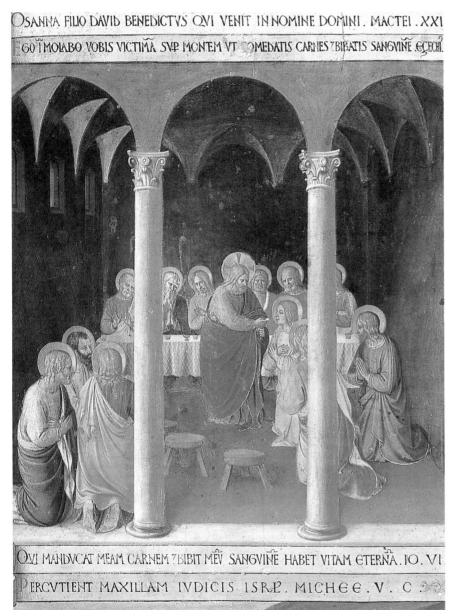

Left: Fra Angelico, Communion of the Apostles.

intimidated contemporaries who had shown promise as younger men.

The first volume of *Modern Painters* was well received. The work established Ruskin's reputation as a critic and was followed by a second volume in 1846. In this instance, Ruskin's interest in fidelity to nature was grafted onto an increasing interest and awareness of the importance of early Italian painting. He fashioned a historical schema that did much to qualify his admiration for the art of the Trecento and Quattrocento periods and link it to a continuing commitment to naturalism in painting. Ruskin isolated four "schools": those of "love" (represented by Fra Angelico); "great men" (represented by Giotto, Orcagna, Ghirlandaio, and Giovanni Bellini); "painting"; and "errors and vices." Ruskin's antipathy toward painting of the sixteenth century was elaborated on in the third volume of *Modern Painters*, specifically in his critique of the Raphael cartoon of the *Charge to Peter*.

RUSKIN'S THEORY

In his work, Ruskin argued that some time around the beginning of the sixteenth century the course of painting went awry, and the fault was largely attributable to Raphael and his successors. Painters before Raphael had been preoccupied with spiritual issues and their exponents had rendered the world with a pious and unaffected simplicity, aiming only to articulate those religious truths. Raphael had grossly distorted those truths to the extent that religious doctrine was represented with an ethereal refinement that distorted and denied the reality of the Gospels. The tradition of over-refined painting had been enshrined in

academic teaching. A handful of modern landscape painters had shrugged off the burden of the Renaissance and had painted the world not according to academic prescription but as it appeared. Moreover, they had aspired to capture within their pictures not simply literal appearance but something of the divine intention that underpinned it.

It was on critical premises such as these that Ruskin defended (or rather coopted) selected Pre-Raphaelite pictures and their painters to justify his own ideas. In a series of critical essays entitled *Academy Notes*, in the *Edinburgh Lectures*, and in subsequent volumes and editions of *Modern Painters*, Ruskin qualified the support he had first offered in *The Times* of 1851. Ruskin believed the Pre-Raphaelite circle, at its best, to have matched the achievements of the early Italian painters who preceded Raphael. The circle was not guilty of archaism; these artists had, in fact, rediscovered some essential truths in painting, and it was hoped that the discovery would put academic doctrine aside for good. Subsequent works by Ruskin, notably *The Stones of Venice* and *The Seven Lamps of Architecture*, elaborated on the moral sanction of early art and architecture and upheld the example of the Middle Ages, both as an artistic and social ideal. The notion is an especially important one and exerted a profound influence on Pre-Raphaelite art and design in the second half of the nineteenth century.

THE EFFECT OF INDUSTRIALIZATION
Hand in hand with an admiration for the esthetic honesty of the art of the Middle Ages went an increasing interest in the character of the society that produced it. The Industrial Revolution precipitated profound social changes during the first half of the nineteenth century, serving to polarize drastically the distribution of wealth in Britain. There emerged a body of critics that, for a wide variety of reasons, denied the value of unfettered progress, and sought intellectual and emotional refuge in the idealise image of a medieval past, a body that included Pugin, Carlyle, and also, notably, Ruskin.

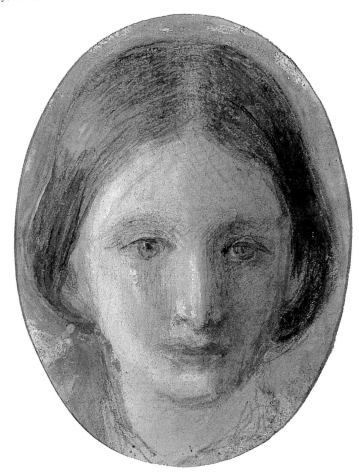

Below: John Ruskin, Portrait of Rose la Touche. *Ruskin's unhappy affair with Rose la Touche, some thirty years his junior, preceded his mental collapse in early 1871.*

Right: John Ruskin, Watercolor Study of
the Chapel of Santa Maria della Spina, Pisa,
*1845. Ruskin favored Gothic over Classical
and Renaissance architecture.*

Below: John Ruskin, Study for Gothic
Window Tracery, *1848. This drawing was
made for the third plate of* The Seven
Lamps of Architecture.

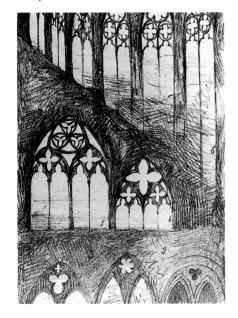

Ruskin used the medium of medieval ar-
chitecture and the system under which it was
made as an incisive tool with which to place
into proper context both ancient and modern
buildings and the societies that produced them.
His appreciation of architecture had much in
common with his appreciation of painting, and
the Renaissance again signified the moment
when European architecture fell from grace.
It was the cold logic with which Renaissance
buidings were constructed, and the way that
logic denied any individual human creativity
to which Ruskin most objected. The Gothic
architecture of the Middle Ages, by contrast,
had not, so Ruskin concluded, been constrained
by regulations, and it was this absence of con-
straint that pointed to the liberty afforded to
medieval craftsmen, who had the opportunity
to plan and decorate a building according to
their creative impulse, and so their labor
involved active thought. This exhortation of
the creative and spiritual benefits of medieval
labour was in stark contrast to working
conditions of the mid-nineteenth century.

THE GUILD OF ST. GEORGE
In 1871 Ruskin attempted to establish a counter
to the excesses of industrialization with the
foundation of the Guild of St. George. The
guild was intended to appeal to anyone who

was sufficiently disaffected by modern society to want to establish some alternative. Ruskin had intended that the fraternity would spread throughout England and beyond and establish a social alternative to industrial capitalism. In fact, the success of the guild was limited to a handful of communities in Wales, Yorkshire, and the Isle of Man. Although it was unsuccessful, the principles on which it was based were of inordinate importance to artists, craftsmen, and architects active during the second half of the nineteenth century, including the "second wave" of Pre-Raphaelites who had gathered around Rossetti and Morris in Red Lion Square in London and later at the "Palace of Art," Red House in Bexleyheath, Kent.

By the mid-1850s, the purpose of the Pre-Raphaelite Brotherhood seemed to be in question: there had been defections and resignations; founder-members such as Millais had doubted its *raison d'être*, and had increasingly lost any sense of common purpose with his comrades; Hunt had left for the Holy Land; and there now appeared to be little consensus in style in the works of the original brethren. In 1854, however, Edward Coley Burne-Junes (1833–98) and William Morris (1834–96) had learned of the movement's work while at Oxford through *The Germ* and Ruskin's *Edinburgh Lectures*, and Pre-Raphaelitism, now centered around the charismatic figure of Rossetti, attracted some enthusiastic and influential converts to its cause.

Right: Sir Edward Coley Burne-Jones, The Wise and Foolish Virgins, *1859. A pen-and-ink drawing with some Classical elements.*

Below: Portrait of William Morris, attributed to Charles Fairfax-Murray. Morris' company was capable of undertaking virtually any 'species of decoration'.

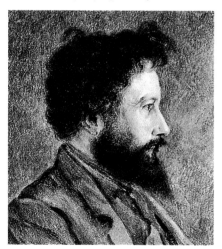

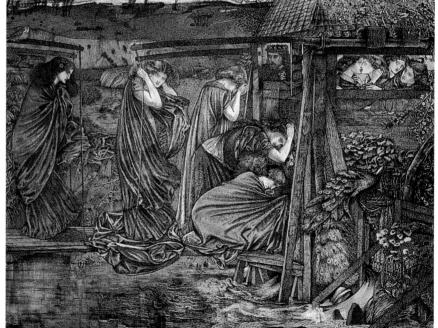

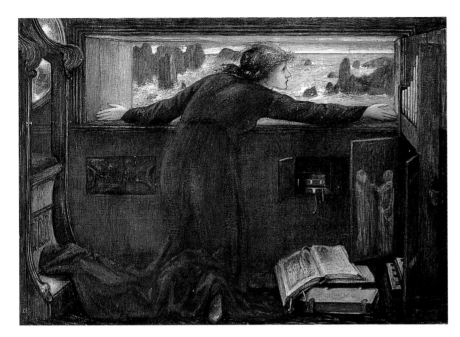

Left: Sir Edward Coley Burne-Jones, Dorigen of Britain Waiting for the Return of her Husband, *1871. At Oxford, Burne-Jones was an avid reader of romances.*

Above: William Morris, Chair in ebonized wood. *This piece of furniture is upholstered in its original woolen tapestry.*

THE MIDDLE AGES RECREATED AT OXFORD

Burne-Jones and Morris had originally met at Oxford in 1853. Both had been profoundly affected by the cult of medievalism that was especially virulent in the university milieu. During their early days at Oxford they had been avid readers of such medieval "romances" as Alfred, Lord Tennyson's *Morte d'Arthur*, Charlotte M. Yonge's *The Heir of Redclyffe*, and Sir Kenelm Digby's manual for the latter-day knight, *Broadstone of Honour*. They had both intended to take Holy Orders and to establish a monastic order dedicated to Sir Galahad. Neither ordination nor monastery ever came to fruition, although the pair's enormously high regard for the Middle Ages as an artistic and social alternative to the course of modern society never remained in doubt and was to exert a marked influence on their careers.

THE MEETING WITH ROSSETTI

William Morris joined the architectural practice of George Edmond Street in 1856. It was during this period that Burne-Jones contacted his hero, Dante Gabriel Rossetti. Rossetti was flattered by the attention, and was to exert so powerful an influence over both Burne-Jones and Morris that the two were persuaded to abandon their respective architectural and academic careers and take up painting; Rossetti had summarily declared that all other methods of expression had run their course. Working under the close guidance of Rossetti, Burne-Jones and Morris shared the top story of his studio at Red Lion Square and began to paint.

Among the earliest works undertaken by the new converts to the Pre-Raphaelite circle (or, more specifically, to Rossetti's circle) were the decorations for some pieces of furniture for the house at Red Lion Square. In 1856 Morris had designed a characteristically "medieval" settle that had been made by a local carpenter and decorated, with Rossetti's help, with scenes from the poetry of Dante and Malory. The scheme prefigures Morris's concern with the applied rather than fine arts by some years.

During the following year Burne-Jones, Morris, and Rossetti went up to Oxford to assist in another collaborative scheme, the decoration of the Oxford Union. Benjamin Woodward, a friend of Rossetti's and a devotee of Ruskin, had designed the Union debating

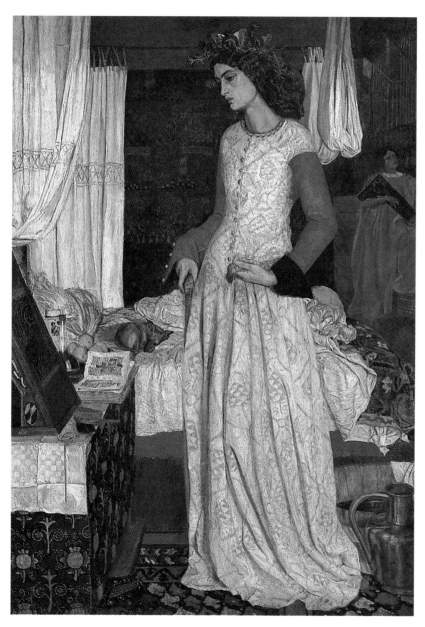

chamber and suggested that members of the Pre-Raphaelite circle might care to decorate its interior. Rossetti mustered a group of enthusiastic acolytes, including Morris, Burne-Jones, Arthur Hughes, Philip Webb, Val Prinsep, Hungerford Pollen, Spencer Stanhope, Alexander Munroe, and Charles Faulkner, many of whom had no professional painting experience. The cycle was to include 10 scenes from the *Morte d'Arthur* executed in the appropriately medieval medium of fresco, with Morris contributing a scene entitled "Sir Palomydes's Jealousy of Sir Tristram." The group undertook the program with great enthusiasm. Little, however, remains of the cycle. Few of its executors knew anything about painting and even fewer knew about the medium of fresco. The cycle, which remained unfinished, deteriorated rapidly.

QUEEN GUENEVERE

A better insight into Morris's fine art of the period is provided by his only extant oil painting, that of *Queen Guenevere* (sometimes called *La Belle Iseult*), painted in 1858. The painting shows Jane Burden, one of a handful of attractive female associates of the Brotherhood (collectively known as the "Stunners"), in the guise of King Arthur's consort. She stands before a crumpled bed that alludes to her adulterous love affair with Sir Lancelot, a theme upon which Morris was to elaborate in a volume of poems, *The Defence of Guenevere*, published in 1858. From a technical point of view, Morris's *Queen Guenevere* leaves much to be desired. The picture, like

Left: William Morris, Queen Guenevere, *1858. Morris's only extant oil painting was eventually abandoned and later completed by Rossetti and Madox Brown.*

most Pre-Raphaelite works, is painstakingly painted, but in this instance done with little obvious flair save for the minute attention paid to the patterns on the tapestry, fabrics, and costumes. Morris apparently loathed the final result. He was keenly aware of the limitations of his own ability and eventually abandoned the work.

ROMANTIC THEMES

The theme of medieval romance dominated the circle's work of the period. Around 1859 Rossetti had finally abandoned *Found*, one of his few paintings with an explicitly moral theme (in this instance, that of a fallen woman), and seemed thereafter to have concentrated on subjects from medieval poetry. *Paolo and Francesca*, a watercolor painted in 1855, is a good example. The picture takes its subject from *Canto V* of Dante's *Inferno* and uses a narrative composition of three sections. *Dantis Amor*, painted in the year that Rossetti finally abandoned *Found*, is executed in a similar idiom. The picture shows an allegorical figure of Love (Amor) holding a crescent dial on which the day and hour of Beatrice's death are inscribed. The highly symbolic composition, strongly reminiscent of the work of William Blake, represents Beatrice's death and her transition from Earth to heaven, as well as what Rossetti believed to be the central theme of both the *Vita Nuova* and *The Divine Comedy*: the notion that Love is the primal spiritual force in the universe.

Medieval romance took an altogether different turn in the unfolding career of William

Right: Dante Gabriel Rossetti, The Blessed Damozel, *1871–79. The predella shows an Earth-bound figure looking up to his recently departed lover.*

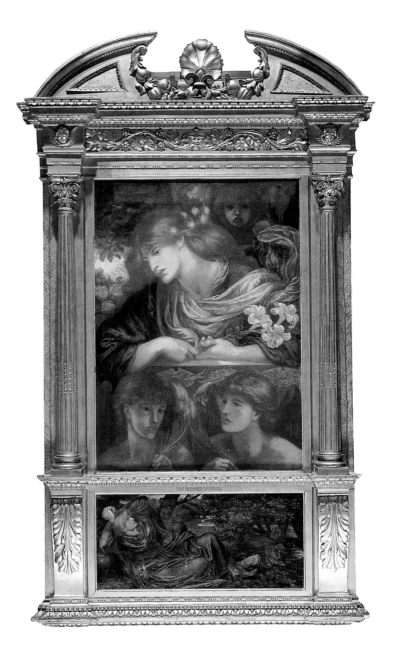

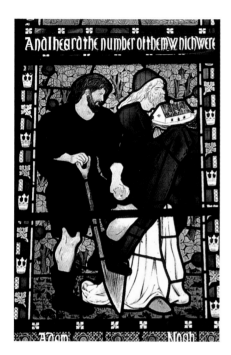

Above: Ford Madox Brown, Adam and Noah. *A stained-glass design made for Morris and Company, 1865.*

Morris. In 1859 Morris married Jane Burden, the model of his *Guenevere*, and in the following year they moved from London to the small village of Upton, near Bexleyheath in Kent. Philip Webb (1831–1915), who started out with Morris in G. E. Street's architectural practice, designed a large country house for the couple in a style quite unlike that of most contemporary Victorian buildings. In the Red House Webb had managed to come up with an alternative idiom that was to exert a powerful influence on the vernacular tradition in domestic architecture for the next 50 years.

The style of the Red House alludes to a medieval precedent, yet it is quite distinct from the absurdly overdecorated designs that often characterized the Victorian High Gothic Revival. The building is constructed in traditional red brick, with a steeply pitched tile roof, and is laid out within an orchard on a right-angled plan, giving the house something of the feel of a monastic cloister.

The interior of the Red House was equally practical: the walls were white-washed, the floors tiled, and from the inside the main room on the first floor was left open to the roof, in order to render the construction of the roof clearly visible.

The Red House was a hive of creativity on the part of a number of Pre-Raphaelites and their associates, although Morris's cherished ambition that the house would become the focus of a pseudomedieval artistic community was not shared by his contemporaries, and the plan came to nothing.

There emerged from the house, however, a more practical alternative to Morris's initial romantic vision. From the somewhat ill-conceived notion that artists of the Middle Ages concerned themselves not just with painting but with many other crafts besides, there evolved the altogether more worldly venture of "Morris, Marshall, Faulkner and Company, Fine Art Workmen."

Right: Philip Webb's the Red House, built between 1859 and 1860, was the home of William and Jane Morris between 1860 and 1865.

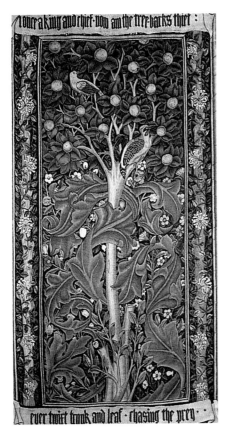

Left: William Morris, Woodpecker *tapestry, 1885. This tapestry incorporates two lines of Morris's verse.*

Below: William Morris and Edward Burne-Jones, When Adam Delved and Eve Span. *The frontispiece for Morris's* A Dream of John Ball, *1888.*

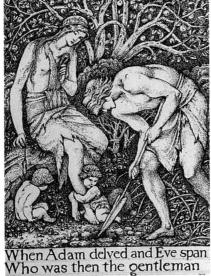

The "Firm," as the venture was popularly known, was established in April 1861 under the direction of Morris, Faulkner, and P. P. Marshall, with Burne-Jones, Rossetti, Webb, and Madox Brown as participants and holders of nominal £1 shares in the company. The Firm issued a prospectus declaring itself capable of undertaking virtually any "species of decoration," including mural painting and the production of furniture, stained glass, metalwork, and embroidery.

It is important to recognize that a marked shift in attitude had begun to occur with the foundation of Morris's company. Earlier Pre-Raphaelite ventures had often used medievalism as a shelter from the horrors of modern society. The aim of the Firm, however, was more ambitious, in that it sought social reform though the medium of the decorative arts. Morris and Company was attracted to the culture of the Middle Ages, but used an essentially Ruskinian understanding of medieval art not as some romantic refuge but as an antidote and alternative to the short-comings of industrial society.

The Firm's products were mostly handmade by artists and craftsmen who (like their medieval forebears) were able to delight in work that had not been subjected to the division of labor necessitated by mechanized production. The Firm continued to produce a wide range of furnishings until it went into liquidation during World War II. In later life, however, Morris's interest in the company began to waver. He increasingly came to realize that the applied arts could not precipitate the changes in industrial society he desired.

THE WORK OF HOLMAN HUNT
The diversity of the Pre-Raphaelite *oeuvre* during the 1850s is demonstrated by the varying interests of those brethren who remained outside Rossetti's influence. The continuation of another important aspect of Pre-Raphaelitism's original creed is found within the work of William Holman Hunt. Hunt was never well-disposed toward the medieval revival that had touched his comrades. Both Hunt and Millais also resented the extent to which Rossetti's peculiarly romantic and sensual brand of Pre-Raphaelitism, underwritten by Ruskin's critical influence, had, at least in the public's mind, appropriated the movement as a whole.

Decades later, Hunt was to attempt to dissociate Rossetti from the true spirit of the movement in an essay, "The Pre-Raphaelite

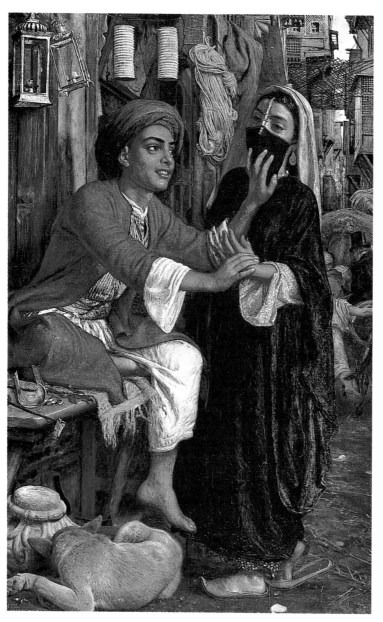

Brotherhood: A Fight for Art," written in 1886. The true spirit to which Hunt referred found form not in flights of romance but in high-minded piety forged with an aggressive naturalism. Like Ruskin (from whose *Modern Painters* Hunt had evolved this extreme sense of naturalism), he believed that painting should aspire to some divine purpose, yet, like Ruskin, he took exception to the manner in which religious painting had invariably sought to mask divine truth behind artistic convention. It was, for Hunt, but a short step from some of the radical reinterpretations of the Gospels undertaken by the circle in 1848 and 1849 to the task of recovering the archeological remnants of the Bible by painting religious art in the Holy Land itself.

Financed by the sale of *The Light of the World* (it fetched £400), Hunt left for Palestine in 1854. He arrived in Cairo, where he painted *The Lantern-maker's Courtship*, a secular picture of an overardent lantern-maker attempting to unmask his prospective bride. The work had a didactic purpose, in that it was partly an attempt to use the medium of painting to spread knowledge of other cultures and, Hunt explained, partly a "trial of the question of getting models." In this instance, Pre-Raphaelite verisimilitude had run headlong into the Islamic culture's averison to figure painting.

THE HOLY LAND

Both *The Lantern-maker's Courtship* and *The Afternoon in Egypt*, an allegory of abundance, were made in preparation for far more ambitious pictures. In May 1854 Hunt arrived in Palestine; in July he began *The Finding of the*

Left: William Holman Hunt, The Lantern-maker's Courtship. *This painting was exhibited at the Royal Academy in 1861.*

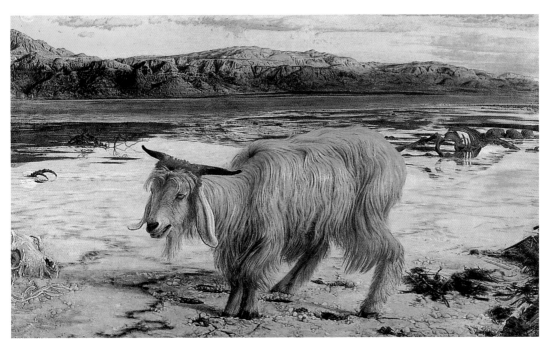

Left: William Holman Hunt, The Scapegoat, *1854. Hunt depicted his outcast subject against the lifeless shores of the Dead Sea in the Holy Land.*

Savior in the Temple, the first religious picture to be painted in the location where the incident was thought to have taken place. The subject (Christ's discovery in the temple by Mary and Joseph as recounted by Luke) was informed by extensive research into the writings of the Jewish historian Josephus, the Bible, the Talmud, and John Lightfoot's mid-seventeenth-century study on Hebraic ritual, *The Temple Service as it Stood in the Dayes of our Saviour*. In addition, Hunt had visited synagogs and had attempted to use only Semitic models. The work progressed very slowly, with some of the figures, Mary and Christ for instance, being painted on Hunt's return to England in 1856; as yet incomplete, the painting was eventually put to one side.

Shortly after having postponed work on *The Finding of the Savior*, Hunt left Jerusalem on a treacherous journey to Usdam, on the shores of the Dead Sea, to begin *The Scapegoat*. The source for the picture comes from Chapter XVI of Leviticus, and refers to the ancient Hebraic custom whereby two goats are selected as penitential symbols of human sin. On the Day of Atonement, custom decreed that one goat was to be presented to the temple and the other was eventually driven into the wilderness and sacrificed.

THE SCAPEGOAT

Hunt's picture shows the sacrificial goat, depicted against the lifeless saline shores of the Dead Sea, on a site that was believed to be the location of the city of Sodom. Hunt was here making an intentional link between the city's misdemeanors and those sins invested in the figure of the goat. Hunt extended the allusion even further, with a reference to Christ's own sacrifice for human sin, and his redemptive spirit is symbolized in the picture by the rainbow on the right.

The Scapegoat was not well received at the Royal Academy Exhibition of 1854. The *Art Journal* was very unsympathetic to Hunt's work, and dubbed him, derisively, the "high priest" of the movement. The observation, perhaps fortuitously, was an astute one, for Hunt's *Finding of the Savior* and *The Scapegoat* had taken Pre-Raphaelitism to its ultimate conclusion. The original requirement that art should both study nature attentively and have genuine ideas to express had assumed within Hunt's work what can be described as the

Right: Ford Madox Brown, Work, *1852–63. This was an ambitious painting which Brown annotated with a lengthy essay.*

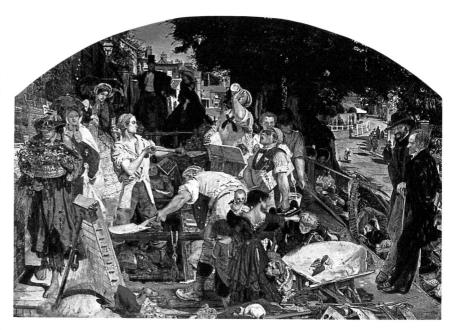

status of pictorial evangelism, demonstrating that the life of Christ and the Gospels were real historical events tethered to a specific geographical locale.

The influence of Pre-Raphaelitism and, more specifically, Ruskin's interpretation of it, spread as other painters, largely on the periphery of the Pre-Raphaelite circle, began to adopt a naturalistic style. Henry Wallis painted *The Stonebreaker* in 1857 and the theme of rural labor also appeared in John Brett's *The Hedger*.

WORK

Perhaps the most famous picture on the subject of the Victorian preoccupation with labor is Ford Madox Brown's ambitious allegory, *Work*, painted between 1852 and 1863. The painting cataloged the various manifestations of labor in mid-Victorian England, rounded up, in this instance, beside the excavation that took place for the laying of water pipes at Heath Street, Hampstead, a northern suburb of London.

The heroic navvy in Brown's *Work* is flanked by people of various stations in Victorian society: on the left side of the picture is a poor flower-seller; on the extreme right stand two "sages" ("the cause of well-ordained work and happiness in others"). These sages are F. D. Maurice, the Christian Socialist and founder of the Working Men's College, and Carlyle. Toward the top of the painting, Brown has also included the rich who do not need to work. At the opposite extreme of the social spectrum are the group of orphans who are being marshaled by their 10-year-old older sister in the foreground, and the idle

laborers under the shade of the tree on the extreme right of the picture. To the left, walking up Heath Street, is a pastry-cook with a loaded tray on his head; he is a symbol of society's surplus wealth. Class antagonism is even evident in the way in which the orphans' faithful mongrel and the pampered whippet are depicted about to face up to one another.

THE PRE-RAPHAELITES' ACHIEVEMENT

Many of the seminal works of British Pre-Raphaelite painting had already been painted by the mid-1860s. The circle's marked disposition toward artistic truth had perhaps seen its finest hour in Hunt's pictures made in Palestine. The movement's equally marked interest in medievalism had been elaborated first in Rossetti's paintings and poetry and later in Morris's experiment at the Red House and the founding of Morris's "Firm."

THE MOVEMENT IN THE UNITED STATES

Pre-Raphaelitism, usually considered a quintessentially British movement, had in the meantime spread to the United States. Ruskin's Low Church esthetic, and his emphasis on naturalism in preference to historical precedent, had a strong appeal to a nation with a well-established tradition of religious independence and little chronological history. It is to the United States, then, that one has to turn to examine the following stage in the history of the movement.

The Final Years of the Pre-Raphaelite Brotherhood

Pre-Raphaelitism appears, at first sight, to be a quintessentially historical style dependent upon a well-rehearsed idea of the distant past. It evolved in a cultural climate that could trace its origins back not only through centuries, but millennia. It is perhaps surprising, therefore, to see a markedly original reworking of Ruskinian and Pre-Raphaelite ideas occurring in the United States, a nation which, in the mid-nineteenth century, was less than a hundred years old.

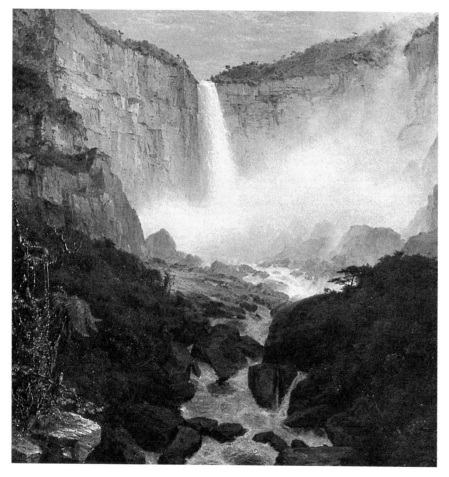

Ruskin's *Modern Painters* was published in the United States in 1847. Some critics took exception to Ruskin's summary dismissal of the European academic tradition. Many Americans, however, were of a more independent turn of mind, for *Modern Painters* appears to have been received with great enthusiasm and interest. Ruskin's supporters had found within *Modern Painters* a theoretical vein that was especially germane to their own cultural position. Americans were psychologically dependent upon European culture but, being thousands of miles away from their spiritual home, had little means of maintaining any real connection. There emerged around the middle of the century a debate in which Americans were forced to choose between asserting a bond with Europe or hewing out a new and independent path of their own. It was in this context that Ruskin's ideas exerted so strong an appeal.

AMERICAN NATURALISM

Modern Painters upheld to artists the example of the ahistorical, natural world in preference to the example of other art, and provided American artists with an esthetic standard remote from the values of European academies. As a consequence, Americans could paint and appreciate the immediate natural world around them, simultaneously forging a new painting style distinct from any European precedent. Ruskin's work was also to concur with American cultural interests on the spiritual as well as the naturalistic fronts. It is,

Preceding page: William John Hennessy, Mon Brave, *1870.*

Left: Frederick Edwin Church, The Falls of Tequendama, *1854.*

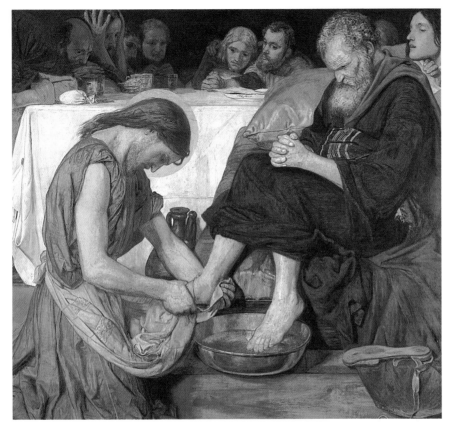

Ford Madox Brown, Christ Washing Peter's Feet, *1851–56. A watercolor study of Brown's oil painting was exhibited in Boston in 1857.*

then, easy to appreciate why Ruskin found in the United States so attentive an audience, and why the critic John Durand credited Ruskin with doing more for disseminating a concern for painting in the United States than any other agency.

Those American critics and painters who were well disposed toward Ruskin invariably adapted his writings. The carefully selective appreciation of Ruskin's writing is especially evident in the reception given to the practical rather than the theoretical Ruskinian theory that came to the United States with the traveling exhibition of British art organized by Augustus A. Ruxton in 1857. Pre-Raphaelite painting was represented in the exhibition and appeared to have attracted far greater attention than more conservative works. The exhibition included several seminal examples of Pre-Raphaelite painting, such as Hunt's *The Light of the World,* but also included some more demanding artistic works, like Brown's *Christ Washing Peter's Feet* and also Elizabeth Siddal's *Clerk Saunders.* Such examples clearly placed considerable demands upon a new audience.

LANDSCAPE PAINTING

William James Stillman, writing in *The Crayon,* thought English Pre-Raphaelitism generally in keeping with American sensibilities, but bemoaned the absence of landscape painting. This marked disposition towards landscape also served to elevate other, now largely forgotten, painters, like William Davis, Thomas Sutcliffe, W. S. Rose, and also

THE FOUNDATION OF THE ASSOCIATION

The Association evolved out of a series of informal meetings among artists, critics, and amateurs. These meetings gradually expanded to include the painters John William Hill (1812–79) and his son John Henry Hill (1839–1922), William Trost Richards (1833–1905), Charles Herbert Moore (1840–1930), Henry Roderick Newman (1843–1917), and the influential art critic Clarence Cook. On January 27, 1863 one such gathering attempted to establish some common purpose among its members and to clarify an artistic policy. The nascent Association, which was infinitely better organized and more clear-sighted than its English counterpart, then drafted a series of articles and elected a committee to help achieve this purpose.

THE AIMS OF THE ASSOCIATION

In its aims, the Association sought to sever all links with artistic tradition, and to fashion a native American idiom according to the naturalistic standards upheld by Ruskin and the Pre-Raphaelites. A confident and independent American style would be afforded, the Association insisted, by a program of art education, exhibitions, and public instruction in both the applied and the fine arts. These objectives were set out in detail in the Association's journal, *The New Path*, first published in May 1863. The opening statement of the title page of the first issue, written by Clarence Cook, stated that: "The future of Art in America is not without hope . . . The artists are nearly all young men; they are not hampered by too many traditions, and they enjoy

W. T. Bolton. In the United States the arcane mysteries of symbolism or medievalism that had so engrossed British painters meant little; for the American audience, landscape exemplified Pre-Raphaelitism at its most articulate. It is hardly surprising, then, to discover that when American painters constituted their own fraternity along the lines of the English Brotherhood they were almost exclusively concerned with that one genre.

In January 1863 a group of artists and amateurs centered around the studio of the painter Thomas Charles Farrer (1839–91), a one-time student of Ruskin at the Working Men's College in London, founded the Association for the Advancement of Truth in Art, a fraternity directly inspired by the example of the Pre-Raphaelite Brotherhood in England. Like the English Pre-Raphaelites, the majority of the members of the Association had been with an academy, in this instance New York's National Academy of Design, and appear also to have been inspired by a similar spirit of secession. In an almost millennial summary of the annual exhibition of 1863, the Association dismissed the efforts of the National Academy and confidently looked forward to the radical new initiatives of young American painters.

the almost inestimable advantage of having no past, no masters and no schools." Moreover, America's painters had the advantage, Cook insisted, of working for an uneducated public, unburdened with the artistic prejudices that clouded the vision of European spectators. At times the editorial tone of the journal rose from one of stridency to outright aggression. It was the Association's function, stated in an article published in January 1864, to challenge academic complacency at all costs; its very purpose was to destroy undeserved reputations, and to promote discord and dissatisfaction among both artists and their public. In contrast to the covert Pre-Raphaelite Brotherhood, the Association made a full-scale assault on the academic establishment.

NATURALISTIC TECHNIQUES

Ruskin was a constant point of reference for the Association, but was again used selectively by artists and critics, who focused primarily on his call for fidelity to nature. They were unanimous in the belief that painstaking naturalism was the prime point of departure for sound painting and nothing of value could be achieved without it. It is symptomatic of *The New Path*'s asceticism that the course taken by the Association was a testing one. The highly finished technique advocated by *The New Path* was very labor-intensive and demanded astounding powers of concentration. In addition, these pictures had, of necessity, to be completed in the open air, often in inclement weather. The finished work, having taken so long to produce, would inevitably yield a poor financial return.

Left: Thomas Charles Farrer, Practising her Lesson, *1859. Farrer had studied in London under Ruskin.*

Right: Thomas Charles Farrer, Mount Tom, *1865. This New England vista was painted with remarkable attention to detail.*

Below: John Henry Hill, A Study of Trap Rock, *1863. This work was executed on location in New Jersey.*

NATURAL INSPIRATION

The pictures produced by the American Pre-Raphaelites fall into very distinctive categories quite separate from the work of their English counterparts. Few of the artists connected with the Association, for example, worked from the human figure. Instead they concentrated on either extensive landscapes or intensive nature studies, showing minutely detailed concentrations of flower, fruit, and occasionally animal life.

The work of Thomas Charles Farrer is exceptional, and his pictures are perhaps closest in aspiration to the work of the English Brotherhood. *Practising her Lesson,* drawn in 1859, shows a young woman at a piano with her back to the audience and her face reflected in an elaborate mirror. The drawing is made with meticulous and indiscriminate attention to detail but includes no symbolism and no moral whatsoever. *Gone! Gone!,* painted in 1860, is a closer approximation of English Pre-Raphaelitism; the artist has even acknowledged the lineage of the picture by inserting an engraving of Millais' *A Huguenot, on St. Bartholomew's Day* on the wall on the right-hand side of the painting.

Farrer's contribution to American Pre-Raphaelitism is somewhat atypical, in that the majority of his contemporaries confined themselves to pictures of the immediate natural world. The work of John Henry Hill serves a typical example. His *A Study of Trap Rock* of 1863 shows an outcrop of trap rock surrounded by dense vegetation. Other than the fact that Hill is bearing witness to the divine creation,

the picture has no moral content. This sense of materialism also characterizes the works of many of Hill's contemporaries, including, in some instances, Farrer. Farrer's *A Buckwheat Field on Thomas Cole's Farm* (1863) and *Mount Tom* (1865) depict two extensive New England vistas rather than microscopic studies of nature, although both are executed with the same unflinching attention to detail.

Precisely the same principles used in the painting of landscape were applied to representations of still life. The Association's artists located their studies of flowers or plants in their natural settings. The paintings can, in some respects, be classified not as still lifes, but rather as landscapes with a remarkably restricted field of view. John William Hill's study of a bird's nest and dogroses made in 1867 is typical of its genre. The picture, executed in watercolor on a small scale, focuses attention on a fragment of a hedge. Hill, Richards, Moore, and Hunt each produced a number of equally detailed studies of this type. The genre is, in some respects, peculiar to the Association.

The achievements of the Association, despite the production of some breathtakingly realistic pictures, were somewhat limited. The psychological insights, sexual frustrations, and idealized political and social dreams that had animated English Pre-Raphaelitism could not

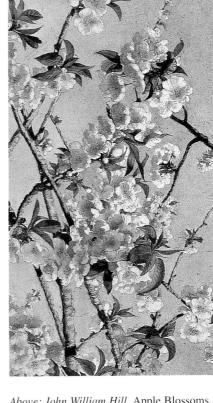

Above: John William Hill, Apple Blossoms, *1874. The American artists painted their still-life studies in their natural settings.*

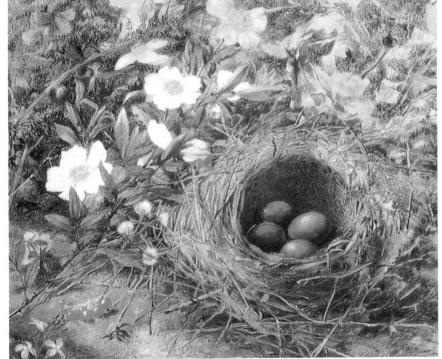

Left: John William Hill, Bird's Nest and Dogroses, *1867. In many respects, this is more a landscape painting than a still life.*

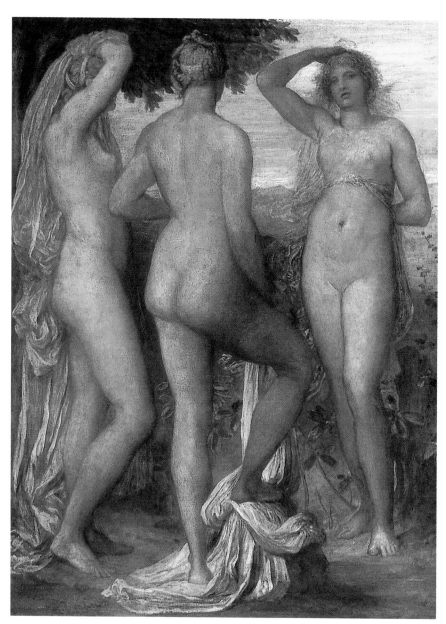

Left: George Frederick Watts, The Judgement of Paris.

be admitted readily into the *oeuvre* of its American counterpart for the simple reason that these concerns were largely immaterial. In 1865 *The New Path* published its last edition. The Association itself, now independent of the journal, rapidly lost its momentum. Despite the Association's limited achievements, some of the principles it held dear continued to play an important role in American cultural life. The search for a style of painting that was free from the influence of Europe continued to preoccupy later American painters and finally found form in the work of the Abstract Expressionist school.

THE DEMISE OF PRE-RAPHAELITISM

In Britain, Pre-Raphaelitism's demise was much less spectacular than its inception. The interests of the individual brethren became increasingly varied, until little trace of the original Brotherhood remained. The movement had emerged out of the Romantic currents in European art, literature, and thought. The same current of Romanticism, more virile and well articulated than the Pre-Raphaelite cause had ever been, finally absorbed most of its offspring.

The career of Sir Edward Coley Burne-Jones serves to demonstrate not only the thorough diversity of the Pre-Raphaelite *oeuvre* but also the degree to which it accorded with currents of Romantic art in England and abroad. Burne-Jones had initially worked with Morris's circle. Unlike Morris, he had continued to paint, and evolved a distinctive style quite independent from that of his colleagues. Burne-Jones's style is far from the amalgam and naturalism found in early examples of Pre-Raphaelite painting. His pictures of the

late 1860s and early 1870s are finely wrought, highly formalized figure studies variously reminiscent of the works of Giorgione, Botticelli, and Michelangelo.

RUSKIN'S "UNCONVERSION"

Burne-Jones's style had been formed, in part, through Ruskin's influence, although it is important to recognize that the critic's later concerns were quite different to those expounded in his earlier writings. In around 1858 Ruskin had become "unconverted" from the Evangelical doctrine. This loss of spiritual faith had prompted a profound revision of his esthetic ideas, and Ruskin now took an abrupt exception to medieval art. Instead he extolled an agnostic humanism and upheld the examples of Classical Greek art and Venetian painting, maintaining that a quintessential creative bond could be found between the apostolic examples of Phidias, Orcagna, Giotto, Titian, and Tintoretto. He had, in fact, thus moved perilously close to an approach that had been vilified universally by earlier Pre-Raphaelites, that is, the pagan formalism manifested by the High Renaissance.

Burne-Jones's *The Wise and Foolish Virgins* (1859) contains evidence of Ruskin's revised position. It is significant that Burne-Jones has selected a biblical theme but has depicted the figures strung out through the composition in the manner of a Classical frieze. In most of his later works, an often ill-defined theme merely provides an excuse for a highly wrought arrangement of beautiful but rather introspective young men and women, and the pictures impart a mood or sentiment rather than a particular moral or tale. In *The Golden Stairs*, painted between 1876 and 1880, 15 anonymous young women holding a variety of musical instruments descend a curved stone staircase. The picture has no overt content or allegorical message and the artist has focused attention on the picture's lyrical form.

Sometime in around the late 1870s, the Gothic style, with its wealth of historical and moral connotations, began to be upstaged in favor of a more amoral and abstracted attitude to art and architecture. The notion that art might exist for its own sake, independent of some moral purpose, had initially been imported from France into England by Algernon Swinburne, and was endorsed first by Walter Pater and later by Oscar Wilde. Advocacy of this amoral alternative to Victorian sentiment was popularly known as "Aestheticism." British Aesthetes held the value of esthetic sensation irrespective of the morality of its cause; the disposition found an extreme form, for example, in the exploration into uncharted realms of sexual excess in the poetry of Swinburne and the designs of Aubrey Beardsley. These arguments, perhaps summarised by the catchphrase "art for art's sake," seem somewhat abstracted and difficult to grasp. It is useful to compare Pater's interest in the formal and abstract qualities of paintings with the form of music, which can be enormously evocative, yet it rarely communicates to us in a literal sense. It is perhaps significant that many contemporary painters, Burne-Jones and Whistler among them, made this comparison themselves, with Whistler going so far as to title his pictures with such evocative and lyrical musical terms as "Nocturne" and "Symphony."

RUSKIN VERSUS WHISTLER

The venue associated with Aestheticism in the late 1870s and 1880s was London's Grosvenor Gallery, established in 1877. The new establishment quickly became associated with more

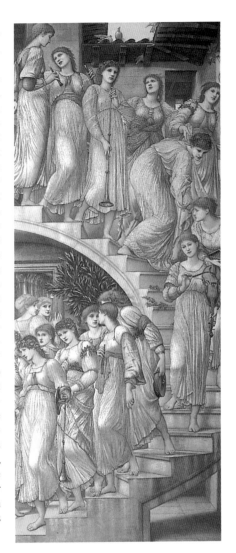

Above: Sir Edward Coley Burne-Jones, The Golden Stairs, *1876–80. This image's lack of allegorical message mystified many contemporary viewers.*

progressive trends in painting, but the gallery's fame was primarily dependent upon its two most famous sons, Whistler and Burne-Jones. It was here that Whistler exhibited the picture that prompted Ruskin's ire, *Nocturne in Black and Gold*, in 1877, a study of fireworks exploding in the night sky over the Italian town of Cremona. The picture was an exploratory one and, although a landscape, there were a few figurative references within the composition. Ruskin accused Whistler of "flinging a paint pot in the face of the public." Whistler sued Ruskin and a court case followed. The dispute between Ruskin and Whistler is an interesting one, for it brings into sharp relief the two attitudes toward art in late nineteenth-century England (the one mimetic and naturalistic, the other imaginative and contingent upon the autonomy of the artist).

Although Rossetti's influence on Burne-Jones began to wane as early as the mid–1860s, their respective pictures appear to be motivated by a similar spirit of mystique and melancholy. Among the most poignant of Rossetti's pictures of this period is *Beata Beatrix*, made in memory of his wife, Elizabeth Siddal, after her suicide in 1862.

ROSSETTI'S LATER WORK

The remainder of Rossetti's career was almost exclusively devoted to allegorical images of women, many in the form of devotional portraits. It was during the late 1860s that he began something approximating an affair with Jane Morris, which engendered a number of deeply contemplative and reverential studies of Jane in the guise of literary figures, which include

Right: Aubrey Beardsley, Messalina Returning Home. *Beardsley was a leading light of the Aesthetic movement.*

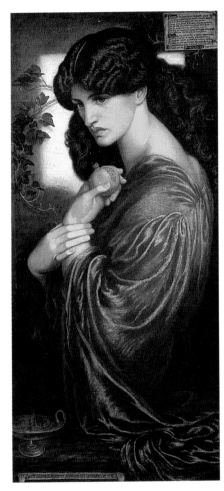

Mariana from *Measure for Measure*; La Pia de' Tolomei from Dante's *Divine Comedy*, and Proserpine, all three of whom had fates as unhappy or constrained lovers. His painted and written portraits of Jane and other "Stunners" are riddled with a vivid physical and sensual appreciation of his subjects, warded off only by guilt and convention. *The Bower Meadow*, painted in 1872, and *La Ghirlandata*, made in the following year, both contain images of languid women playing musical instruments. Rossetti died in 1882, the result of a gradual process of decline.

The cult of Aetheticism, of which Rossetti and Burne-Jones were a part, inspired other members of the Pre-Raphaelite circle. Ford

Above left: Dante Gabriel Rossetti, Proserpine, *1874. The model was Jane Morris.*

Above right: James Abbott McNeill Whistler, Nocturne in Black and Gold: the Falling Rocket, *c. 1875. This picture aroused Ruskin's outrage.*

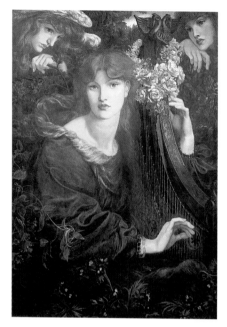

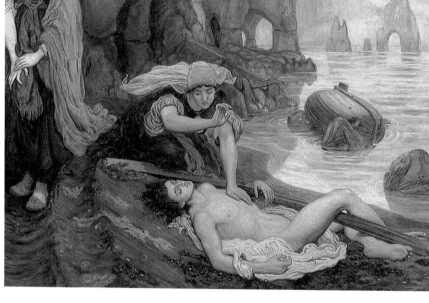

Above: Dante Gabriel Rossetti, La Ghirlandata, *1873. This picture was painted as Morris's home, Kelmscott Manor.*

Above right: Ford Madox Brown, The Finding of Don Juan by Haidee, *1878. The subject is taken from Byron's* Don Juan, *Canto 11, verses 110–12.*

Madox Brown, for example, betrayed in his later works an interest in a linear, stylized design influenced by the cult. *The Finding of Don Juan by Haidee* (1878), for example, is formal and lyrical in design and quite unlike his earlier works. The majority of the younger generation of acolytes who remained within the circle were also, to varying degrees, affected by the cult.

THE PRE-RAPHAELITE DECLINE

The painter and illustrator Simeon Solomon, the painter and poet William Bell Scott, and Spencer Stanhope had all, through a variety of media, betrayed marked affinities toward the sensualism of Rossetti's circle and the Symbolist movement at large, and it appeared that the very notion of Pre-Raphaelitism was, by the latter part of the century, generally connected not with

verisimilitude and naturalism but with the often lurid currency of Aestheticism.

Only William Holman Hunt had the tenacity to continue to apply the principles that had motivated the Brotherhood at its inception. He had undertaken a series of less spectacular but no less consistent pictures, portraits of friends and the painting of London Bridge at night. Hunt was, however, to return to the amalgam of naturalism and historical accuracy applied in his earlier works for another series of pictures planned or painted in the Middle East. In 1869 Hunt made a visit to the Middle East, one of three between 1869 and 1876, where he began, among other works, *The Shadow of Death* and the two versions of *The Triumph of the Innocents.*

The *Shadow of Death* repeats the tried-and-tested formula of a combination of Christian

zeal and archeological truth that formed the backbone of the Pre-Raphaelite *oeuvre* several decades earlier.

HUNT'S BIBLICAL THEMES

Begun on location in Jerusalem in 1870, *The Shadow of Death* is consistent with a branch of inquiry that treated the life of Christ as of historical rather than theological interest. It shows an event that has no direct reference to the Gospels, nor, as Hunt proudly proclaimed, any supernatural element whatsoever. Christ is depicted as having completed a long day's work, his arms outstretched in relaxation. The image of a laboring Savior was an important one for Hunt, and he chose to show Christ in the carpenter's shop as the paradigm of the dignified laborer. Consistent with

the original principles of Pre-Raphaelitism, Christ's repose is anything but straightforward, for in his moment of rest he assumes an eerie posture, that of crucifixion. Lest anyone miss the overt symbolism, Hunt casts Christ's shadow across a wooden rack of tools (symbolic of instruments of the Passion in earlier Pre-Raphaelite works).

Among the most conspicuous of Hunt's other biblical pictures of the period are the two versions of *The Triumph of the Innocents*, painted between 1876 and 1887, and 1880 and 1884 respectively. The pictures are among the most important in the last chapter of Hunt's career and use quite a different formula from earlier works. The two rework the traditional scene of the Flight into Egypt, although in these Hunt's characteristic verisimilitude is

compromised by the inclusion of vision of a calvalcade of Innocents. Hunt clarified his intentions in a written commentary, stating that the Innocents had no corporeal substance and were instead part of a vision accorded to the Holy Family.

The remainder of Hunt's career was less than prolific. Save for *May Morning on Magdalen Tower* (1888–91), *The Lady of Shalott* (1886–1905), and a copy of his much loved *The Light of the World*, which hangs in London's St. Paul's Cathedral, Hunt clarified his ambitions in print rather than paint. Testimony to his understanding of the aims of the Pre-Raphaelite circle and his seminal role within it, so he maintained, as its spiritual and intellectual leader, is his written work *Pre-Raphaelitism and the Pre-Raphaelite*

Left: Spencer Stanhope, Psyche and Charon. *The linear, stylized elements of this painting reflect the later influence of Aestheticism on the Pre-Raphaelite ethos of verisimilitude and naturalism.*

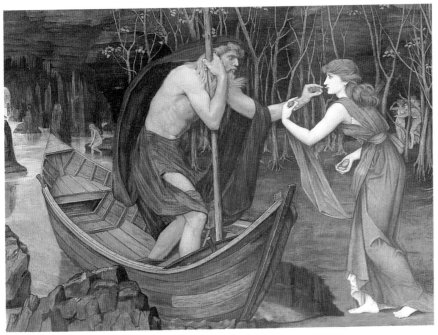

Brotherhood, published five years before his death in 1910.

THE SUCCESS OF MILLAIS

Hunt's memoirs betray the belief that he considered himself the only faithful apostle of Pre-Raphaelitism, working against a tide of Aesthetic and Symbolist affectations that had touched his colleagues and their associates. John Everett Millais was a notable exception, for he was faithful neither to the original spirit of Pre-Raphaelitism nor to its romantic offshoot. Millais, the most conspicuously talented of all the founder-members of the circle, soon lost the radical calling seen in earlier works. He had been profoundly unnerved by the harsh criticism that he had initially received from

the press during the early 1850s, and over the next decade or so he became increasingly timorous in his approach, progressively integrating himself into the artistic establishment. Social and financial success had, however, taken its toll on the quality of his work.

Millais continued to gain the critical approval of Ruskin with the exhibition of *The Rescue* in 1855, a picture celebrating the work of the London Fire Brigade. The melancholy *Autumn Leaves* and *The Blind Girl*, both shown at the Academy during 1856, were also well received. *Autumn Leaves* has no clearly defined subject. It shows a group of children, contemplative in mood, standing around a pile of fallen leaves at dusk. The subject was partly inspired by the poetry of Tennyson and William

Allingham, and contains an obvious allusion to the transience of life and the imminence of death and decay. The child on the right of the picture stares mournfully at the leaves and holds an apple (a symbol of both fall and of the Fall) in her right hand.

THE BLIND GIRL

An equally melancholy but less obscure note is struck in *The Blind Girl*. The picture is concerned with a contemporary preoccupation with vagrancy among the young and disabled; in this instance Millais has dramatically contrasted the blindness of the young girl (who appears within *Autumn Leaves*) with the ravishing beauty of the minutely detailed landscape that surrounds her.

Right: William Holman Hunt, May Morning on Magdalen Tower, *1890. This was one of the few paintings executed by the artist during the last two decades of his life.*

MILLAIS'S FALL FROM GRACE

Millais's exhibition of *Sir Isumbras at the Ford*, painted in 1857, marked a particularly violent fall from artistic grace as far as Ruskin was concerned. The picture shows two children clasped to the side of an ageing knight crossing a ford on his steed. Ruskin balked not only at the size of the mount but also at the slapdash and unrealistic manner in which color had been applied to the landscape.

Millais's decline has not become an accepted part of the Pre-Raphaelite annals, although his fall was far from total and he redeemed himself by a number of absorbing pictures, such as the melancholy study of two nuns digging in a graveyard, *The Vale of Rest* (1858).

Offset against some inconsistent work, the best of which quite clearly lacks the application and purpose of Millais's early painting, are a body of much less compulsive, saccharine, and commercial pictures. They include *My First Sermon*, painted between 1862 and 1863; *Leisure Hours*, exhibited in 1864; *Cherry Ripe* of 1879 (color reproductions of which ran to well over half a million copies); and society portraits, such as *Hearts are Trumps*. The corpus also comprised other essential, but hardly worthy, components of the Pre-Raphaelite canon: works such as *The Boyhood of Raleigh* and *Soap Bubbles*, the apotheosis of Millais's singularly popular style.

MILLAIS JOINS THE ESTABLISHMENT

In many respects, it is ironic that Millais's later pictures endeared him to an ill-schooled

Below left: Sir John Everett Millais, Sir Isumbras at the Ford, *1857. Ruskin hated this picture, especially on account of Millais's use of color.*

Below: Sir John Everett Millais, Autumn Leaves, *1855-56. This image is an allusion to the transience of life.*

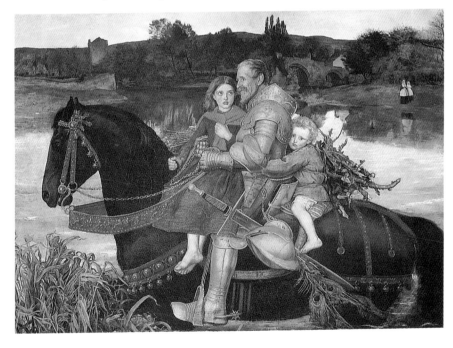

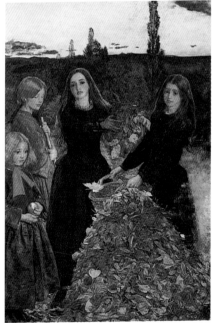

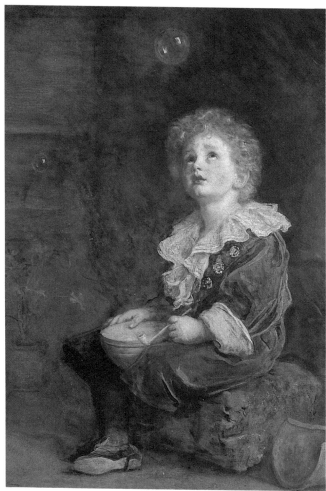

Above right: Sir John Everett Millais, Soap Bubbles. *This painting was the apotheosis of Millais's singularly popular style.*

Above: Sir John Everett Millais, print made from Cherry Ripe. *Such reproductions ran into the hundreds of thousands.*

and philistine public, one which, a generation or so earlier, recoiled at the Brotherhood's zealous attempts to reform British painting.

The antiestablishment banner of artistic reform that had once been carried by Millais and his colleagues was now passed on. The most aggressive and artistic challenges to the bourgeois status quo now occurred abroad, first and foremost in bohemian France.